Tutankhamun's Funeral

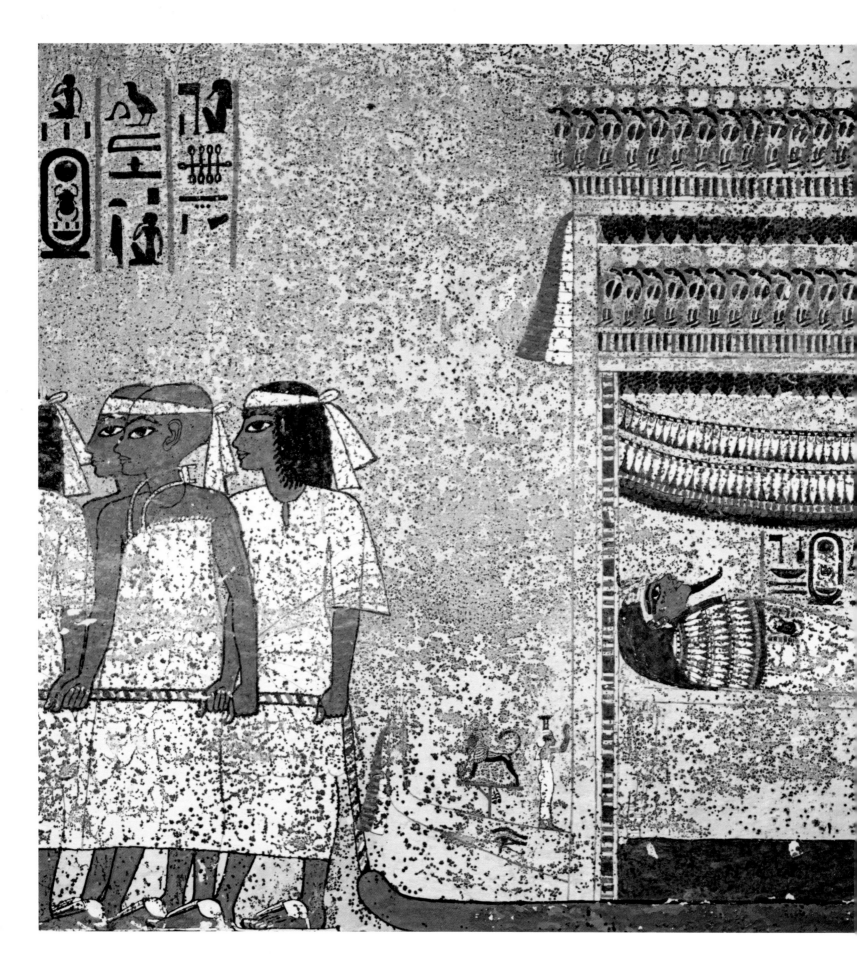

TUTANKHAMUN'S FUNERAL

Herbert E. Winlock

INTRODUCTION AND APPENDIX BY

Dorothea Arnold

The Metropolitan Museum of Art, New York

Yale University Press, New Haven and London

This book is published in conjunction with the exhibition
"Tutankhamun's Funeral," on view at The Metropolitan Museum of Art,
New York, March 16 to September 6, 2010.

The exhibition is made possible by the Gail and Parker Gilbert Fund.

This publication is made possible by The Friends of Isis, Friends of
the Department of Egyptian Art, The Metropolitan Museum of Art.

Published by The Metropolitan Museum of Art, New York
Gwen Roginsky, General Manager of Publications
Margaret Rennolds Chace, Managing Editor
Peter Antony, Chief Production Manager
Nikki Columbus, Editor
María José Subiela, Designer
Félix Andrada, Ediciones El Viso, Production Manager

Typesetting and color separations by Ediciones El Viso, Madrid
Printed and bound by Ediciones El Viso, Madrid

Typeset in Baskerville
Printed on 150 gr Gardapat Kiara

Cover illustration: Head of Tutankhamun, from a statue group
of the god Amun and the king. 18th Dynasty, ca. 1334–1327 B.C.
Limestone, h. 14.9 cm (5⅞ in.). The Metropolitan Museum of Art,
New York; Rogers Fund (50.6)
Frontispiece, page 2: Dignitaries pulling the sledge with the mummy
of Tutankhamun. Painting on the east wall of Tutankhamun's
burial chamber. Detail of fig. 7
Page 8: Tutankhamun's innermost coffin with large floral
collar. Photograph by Harry Burton (MMA neg. no. TAA 1350)

Cataloging-in-Publication Data is available from the Library of Congress.
ISBN 978-1-58839-369-2 (pbk: The Metropolitan Museum of Art)
ISBN 978-0-300-16735-1 (pbk: Yale University Press)

Director's Foreword

TUTANKHAMUN'S FUNERAL ACCOMPANIES AN EXHIBITION AT THE METROPOLITAN MUSEUM of Art that illuminates an intriguing cache discovered in the Valley of the Kings more than a century ago. In 1908, when Herbert E. Winlock encountered the archaeological team of Theodore Davis, he was at the start of his career, newly employed by the Metropolitan Museum and its recently established Department of Egyptian Art. Like Davis and his colleagues, Winlock could not identify the objects and materials unearthed that winter. But when Davis agreed to donate the lot to the Museum, Winlock brought them back to New York, and they became part of the permanent collection. During his research over the next several years, Winlock came to realize the tremendous significance of the finds: These were the remains from the embalmment and last rites of Tutankhamun, the now-legendary New Kingdom pharaoh who reigned briefly in the fourteenth century B.C.

Winlock would rise to become the head of the Metropolitan Museum's Egyptian art department and then Museum director. In thirty years of excavations, plus well over a century of bequests and purchases, the Museum has built one of the most impressive collections of ancient Egyptian art outside Cairo. Loan exhibitions organized by the Museum have further complemented these acquisitions, including most famously the 1978–79 "Treasures of Tutankhamun," which presented the extraordinary riches buried with the pharaoh. (Archaeologist Howard Carter notably cited Davis's find as "one of three distinct pieces of evidence" that encouraged him in his search for Tutankhamun's tomb.)

Yet more than the precious metals and brightly colored stones that dazzle us, it is the simple materials uncovered by Davis—linen sheets, faded flowers, animal bones—that bring us close to the actual physical presence of the pharaohs and their people thousands of years ago. The contents of Tutankhamun's embalming cache are on permanent display in the Museum's Egyptian galleries, but they are doubtless overlooked by many visitors—after all, they must compete with the grandeur of the Temple of Dendur and the brilliance of Princess Sithathoryunet's jewels. The present exhibition, conceived and organized by Dorothea Arnold, Lila Acheson Wallace Chairman of the Department of Egyptian Art, highlights these objects, placing them in context and explaining their significance.

Included in this volume is a 1941 essay by Winlock in which he describes and interprets the find. It is a classic text, by one of the early twentieth century's leading Egyptologists. But, of course, archaeology is an ever-changing field; one discovery leads to another, and each helps explain the one that came before. We are thus fortunate to have Dorothea Arnold's updating, based on recent scholarship, of Winlock's original conclusions.

The Metropolitan is extremely grateful for the support of the Gail and Parker Gilbert Fund toward the realization of the exhibition. We are also greatly indebted to The Friends of Isis, Friends of the Department of Egyptian Art, for making this publication possible.

Thomas P. Campbell

DIRECTOR
THE METROPOLITAN MUSEUM OF ART

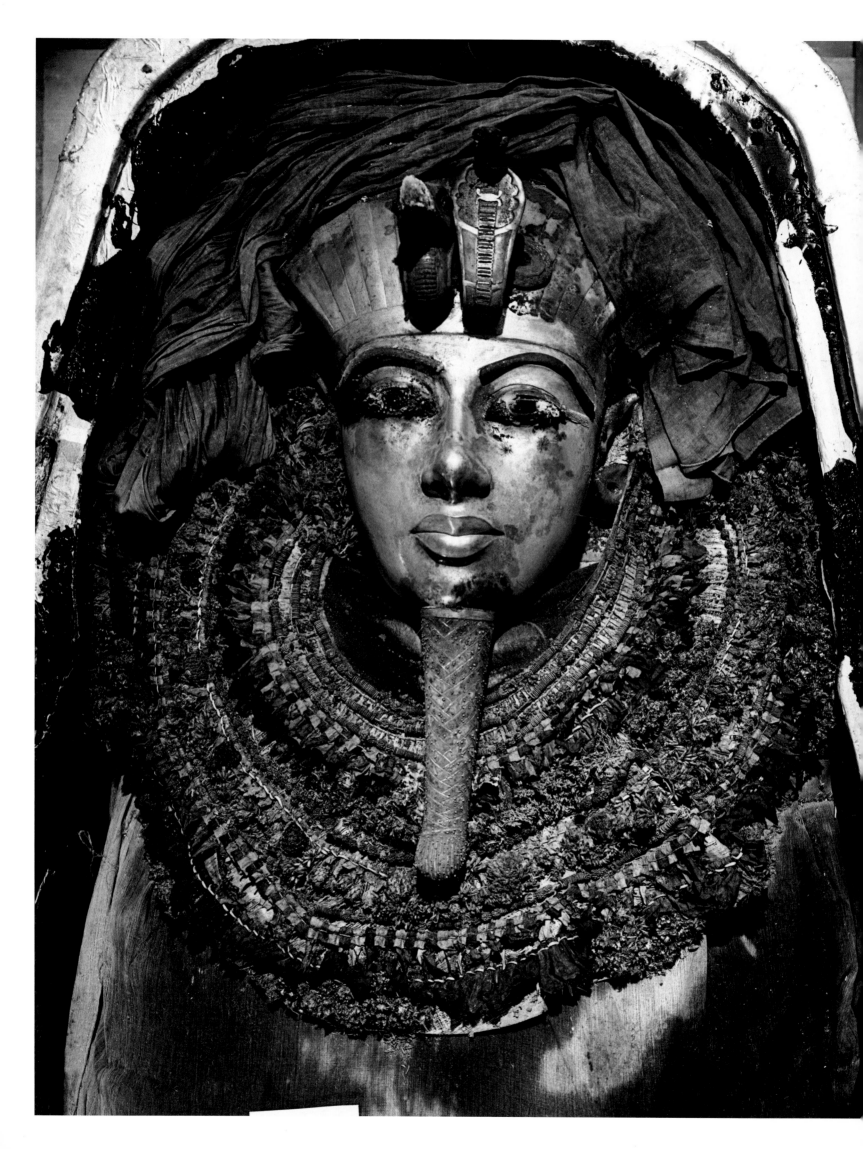

INTRODUCTION

Dorothea Arnold

THE NAME OF TUTANKHAMUN, WHO RULED EGYPT FROM APPROXIMATELY 1336 TO 1327 B.C., is today recognized throughout the world. Although he reigned during the glorious period of the Eighteenth Dynasty (ca. 1550–1295 B.C.), it is not this king's short life that makes him stand out from the ranks of the great pharaohs. Rather, Tutankhamun's fame stems from the extraordinary treasures buried with him after his death. Several thousand objects of precious materials and superb workmanship came to light when Howard Carter and the Earl of Carnarvon discovered the pharaoh's tomb, nearly intact, in 1922. This burial equipment now fills thirteen galleries in the Egyptian Museum in Cairo; a small selection of pieces has toured Europe and the United States in exhibitions attended by millions. Viewers have been awed by the seemingly endless variety of imagery, the glitter of the gold and gemstones, the colorful glass inlays, and the skill of the hundreds of craftsmen who labored over these creations.

However, the invaluable objects that covered the king's mummy and filled the rooms around it reveal only one aspect of the story. By a unique stroke of good luck, remains from Tutankhamun's embalmment and funeral ceremonies have also endured through the ages. When these items were discovered in the winter of 1907–8, in a pit in the Valley of the Kings (subsequently called KV 54), nobody understood their significance; if anything, they were an embarrassment to their finders. It took the sharp eye of The Metropolitan Museum of Art's Herbert E. Winlock to identify the true nature of the objects. He recorded this achievement in the 1941 book that is reissued here after having been long out of print. Now on permanent display in the Museum's Egyptian galleries and highlighted in the exhibition "Tutankhamun's Funeral," these objects and materials provide physical evidence of some of the practical and ritual activities with which the pharaoh's people accompanied his transcendence into the realm of the gods.

Every king was believed to be the incarnation of the god Horus and the son of the solar god Re, but he also had an earthly body that needed to be preserved for the return of his

soul in the afterlife. Thus, a lengthy process took place before Tutankhamun was interred in the Valley of the Kings, the burial site of the pharaohs of the New Kingdom (ca. 1550–1070 B.C.), located on the West Bank of the Nile in western Thebes (opposite present-day Luxor). The ancient Egyptians began embalming their dead as early as 3000 B.C. Although the pharaoh's mummification might have been more careful than a commoner's—and he was certainly more elaborately equipped for the next life—the procedure was, in essence, the same for all Egyptians of reasonable means. First the corpse was thoroughly washed and its organs were removed to be treated separately. Over the course of several weeks,[1] the body was kept packed in natron, a compound of sodium carbonate, sodium bicarbonate, sodium sulphate, and sodium chlorite

FIG. 1 The Valley of the Kings in the 1920s, with the tomb of Tutankhamun in the right foreground. Photograph by Harry Burton (MMA negative no. TAA 2)

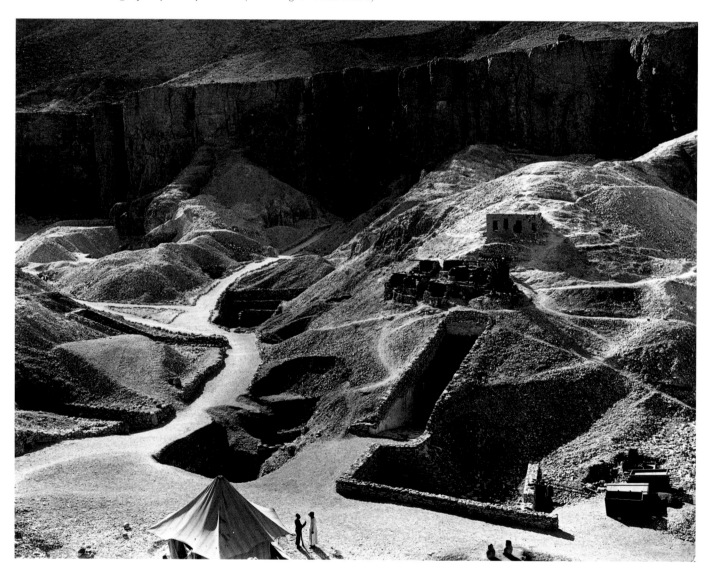

(found in abundance in Wadi Natrun—literally, "Natron Valley" in Arabic—in Egypt's Western Desert) that acts as a desiccant.

After the tissues were dehydrated, the body was again cleaned and treated with resins, herbs, and ointments, some of which probably had antibacterial properties. Linen pads and sawdust-filled linen bags were placed inside the body cavities to maintain the figure's shape before it was wrapped. Layer upon layer of linen sheets and bandages were used to wrap the body—in Tutankhamun's case, some were especially woven for this purpose—and a multitude of amulets, jewelry pieces, and other magically potent accoutrements was enfolded within them. When the wrapping was finished, more jewelry was fastened to the mummy and a mask was placed over its head and shoulders. The organs were also bundled in linen and placed in four containers known as canopic jars.

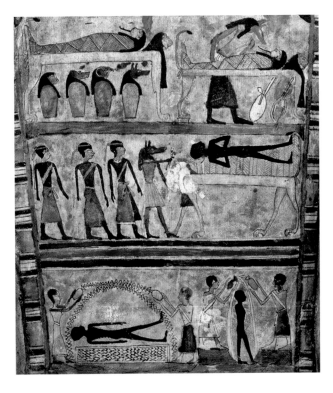

FIG. 2 A rare representation of the mummification process (read from the bottom up). Coffin of the priest Djedbastetiufankh, Ptolemaic Period (2nd–1st century B.C.), El-Hiba. Roemer- und Pelizaeus-Museum, Hildesheim (inv. no. 1954)

Manifold rituals accompanied the embalmment. The following text, for example, appears on coffins from the Middle Kingdom (ca. 2010–1640 B.C.) and thus was already of venerable age by Tutankhamun's death. Although it was not written specifically for a king, it might have been recited during his rites as well:

> Ho [name of deceased]!
> Geb [the god of Earth] will open your blind eyes,
> he will straighten for you your bent knees,
> there will be given to you your heart
> which you had from your mother,
> your heart which belongs to your body,
> your soul which was upon earth,
> your corpse which was upon the ground.
> There will be bread for your body,
> water for your throat,
> and sweet air for your nostrils.[2]

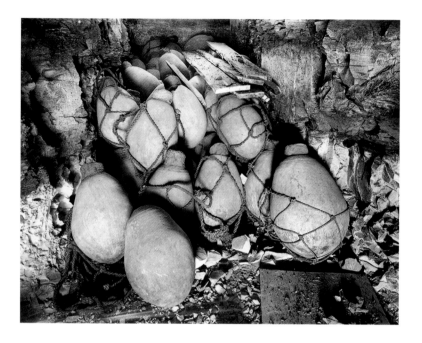

The rituals continued after the mummification was completed, including a nightly vigil and the performance of various symbolic "voyages," though the latter might no longer have been practiced by the time of Tutankhamun.[3] The archaeological finds presented in this book reveal what happened next. The leftover sheets of linen and bandages, little sacks containing extra natron and sawdust, and other items such as the head covers worn by the embalmers and unused adornments like the floral collars were swept up and deposited in large ceramic containers to be buried in or near the tomb (fig. 3). This was not, of course, a simple matter of trash disposal; it reflected a belief that even traces of a person's physical remains contain something of his identity.

Found alongside the materials left over from Tutankhamun's embalming process were broken pieces of pottery and animal bones that provide evidence of another part of the pharaoh's funeral. In the essay that follows, Winlock uses these artifacts to create a fascinating reconstruction of ancient Egyptian life: a funeral banquet attended by eight people wearing floral collars. Unfortunately, this picture does not hold up under the scrutiny of present-day scholarship. Winlock was much influenced by the ubiquitous depictions of banquets in Eighteenth Dynasty Theban tombs, but, eleven years after the publication of his essay, Siegfried Schott demonstrated that these images in fact illustrate a festival that was celebrated annually in Thebes.[4] (See "Updating Winlock," p. 72.)

Reliefs and paintings from the time of Tutankhamun's reign do reveal, however, that it was customary at funeral celebrations to set up small kiosks or booths with offerings of bread, meat and fowl, beer, wine, and water (figs. 4, 5). Although these depictions illustrate nonroyal burial rites, it can be assumed that this practice was followed at a pharaoh's funeral as well. Interestingly, the pictorial representations also show that after the ceremony was concluded, the attendants smashed all the vessels (fig. 5).[5] Given the highly emotional gestures of the attendants, this might look like a final paroxysm of grief, but that type of destructive

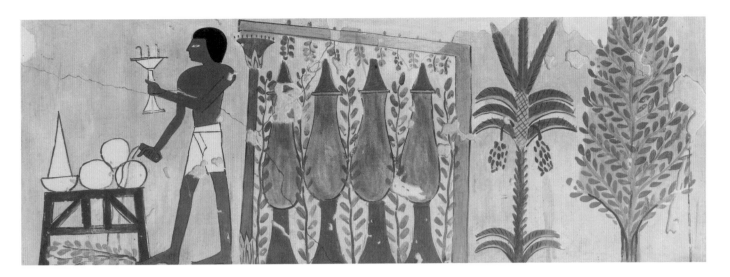

FIG. 4 A funeral ritual in a garden, detail of fig. 6, showing a table and booth with food offerings

act was believed to offer protection during birth, marriage, death, and other life passages.[6] The rituals described here, then, provide an explanation for the animal bones and broken pots found inside the cache's large containers.

Some depictions show offering booths and vessels in conjunction with the funerary cortege that followed the coffin to the tomb, which would suggest that they flanked the way through the necropolis.[7] Other images, however, portray them at rituals involving the deceased's statue in a gardenlike environment with trees growing around a pool (fig. 6);[8] the greenery indicates that neither the barren Valley of the Kings nor even a spot along the desert route toward the tomb could have served as the location of the statue rituals for

FIG. 5 The smashing of the pots after funeral rituals. Relief in the tomb of Haremhab, Saqqara, 18th Dynasty, ca. 1336–1327 B.C. This tomb was built before Haremhab became king. Drawing from Geoffrey T. Martin, *The Memphite Tomb of Horemheb, Commander-in-Chief of Tut'ankhamūn* (London, 1989), vol. 1, pl. 123

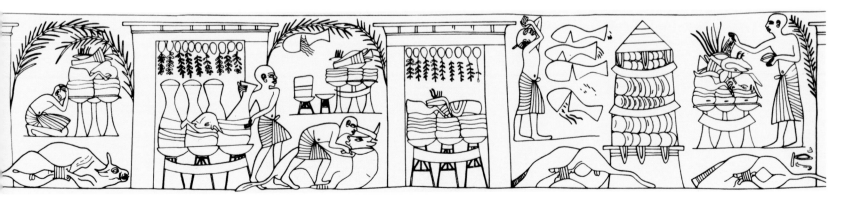

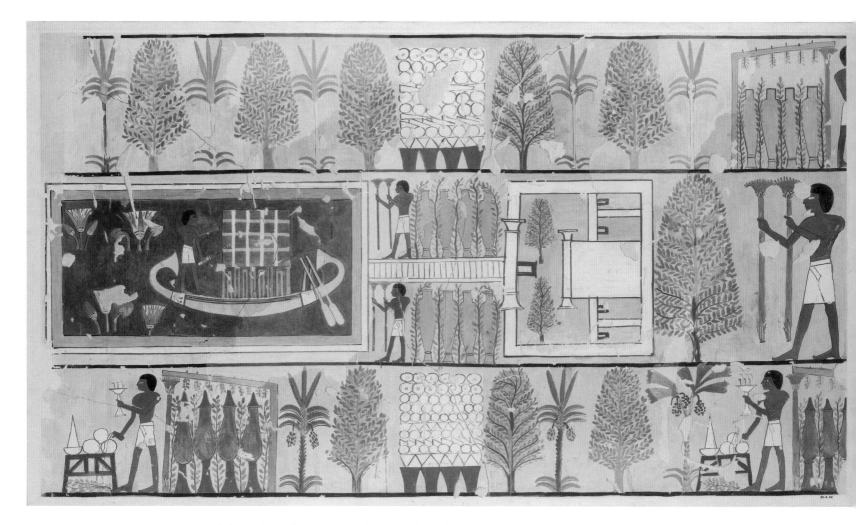

FIG. 6 A funeral ritual in a garden. A statue of the deceased is in the shrine on the boat. Wall painting in the Theban tomb of Nakhtmin (TT 87), early 18th Dynasty, ca. 1450 B.C. Facsimile painting by Charles K. Wilkinson, 1921. The Metropolitan Museum of Art, New York; Rogers Fund, 1930 (30.4.56)

Tutankhamun. Rather, the likely setting for such rites at Tutankhamun's funeral was the king's mortuary temple. The exact site of the temple is not known, nor is it certain how far building activities had advanced when the young king died,[9] but it was no doubt located close to the agricultural lands where other mortuary temples of New Kingdom pharaohs were erected, several miles east of the Valley of the Kings. The mummification of the pharaoh probably was undertaken in the neighborhood of the temple as well. Indeed, the theory that the embalmment and the rites related to the offerings and breaking of the vessels occurred in the same setting best explains why their remains were found buried together. If any meal took place during the king's funeral, it would also have been in conjunction with the statue rituals. Some nonroyal depictions dating to the Eighteenth Dynasty seem to indicate the celebration of such a communal repast in the presence of the effigy of the deceased (fig. 72; see "Updating Winlock," p. 72).

14

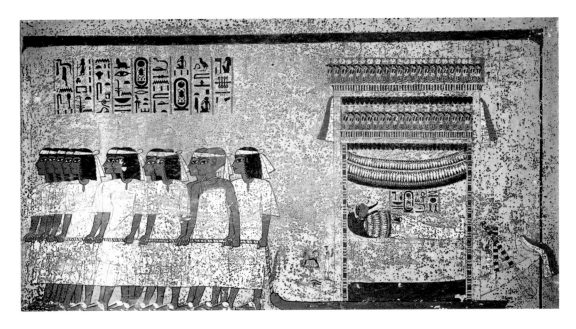

FIG. 7 Dignitaries pulling the sledge with the mummy of Tutankhamun. The two bald figures represent the viziers of Upper and Lower Egypt. The inscription above the men ends with the words, "In one voice: Nebkheperure [Tutankhamun's throne name], come in peace, o god, protector of the land." Painting on the east wall of Tutankhamun's burial chamber

In the end, the whole lot of leftovers from the embalmment and statue rites was packed up and conveyed on the shoulders of servants and attendants to the Valley of the Kings, along with the pharaoh's mummy and his treasures; depictions of nonroyal funerals often contain representations of the long cortege of men bearing funerary equipment to the

FIG. 8 Upper register: the funerary cortege of the priest of Amun, Pairy; lower register: purification of his and his wife's mummies and the "Opening of the Mouth" ritual performed for his statue. Wall painting in the Theban tomb of Pairy (TT 139), 18th Dynasty, ca. 1390–1352 B.C. Facsimile painting by Nina de Garis Davies, 1935. The Metropolitan Museum of Art, New York; Rogers Fund, 1935 (35.101.3)

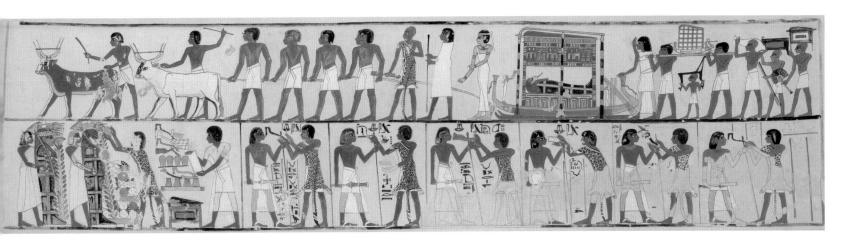

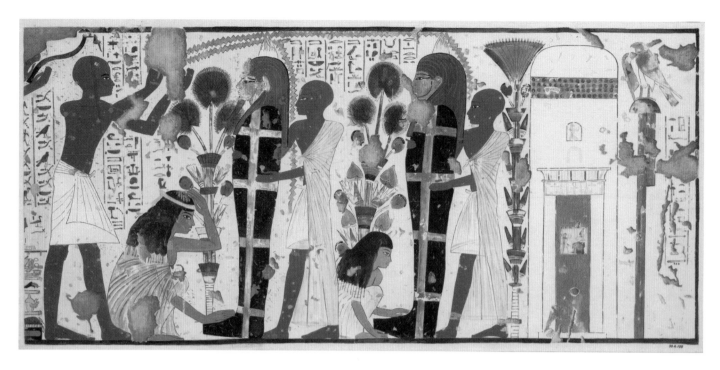

FIG. 9 A purification ritual performed on the mummies of Nebamun and Ipuky at the entrance to their tomb. Wall painting from their Theban tomb (TT 181), 18th Dynasty, ca. 1390–1349 B.C. Facsimile painting by Charles K. Wilkinson, 1920–21. The Metropolitan Museum of Art, New York; Rogers Fund, 1930 (30.4.108)

tomb in the Valley of the Kings (figs. 7, 8). There the final rites took place, just before the mummy was lowered into the crypt. The "Opening of the Mouth" ceremony was performed by the deceased's son—or, in Tutankhamun's case, his successor, Aya—while the mummy was held in an upright position at the tomb entrance (figs. 9, 10). At the climax of the ceremony, the heir held a symbolic instrument, shaped like a carpenter's adze, to the face of the mummy; the dead body was thus reanimated and able to receive the offerings necessary for life after death.

Upon the conclusion of the last rites, Tutankhamun's mummy was deposited into a series of three nested coffins and then into a magnificent stone sarcophagus, over which four elaborate gilded shrines were erected.[10] Until very recently most scholars believed that after all the treasures had been moved inside, the large jars containing the leftover embalming material and offerings were placed along the entrance passage of the tomb. The supposition, which is contrary to that put forth by Winlock, was that the priests moved the pots to the small pit now known as KV 54 only after the tomb was robbed. Arguments for this reconstruction rested on the finds of shards of large pots, linens, and other remains, similar to the ones buried with the embalming material, in the corridor of Tutankhamun's tomb and on the fact that embalming material was found inside at least two other tombs of roughly the same period in

the Valley of the Kings (KV 36 and 46).[11] However, in 2004 a cache much like the one described here was discovered in the royal necropolis (KV 63), containing only pots and coffins filled with the remains from embalming procedures as well as broken vessels and floral collars.[12] Thus, the possibility must be considered again that KV 54 is the original and only location for these materials. However this scholarly discussion will be resolved, at some point during or after Tutankhamun's funeral, the vessels packed with the remains of embalmment and ritual offerings came to rest in the small pit where they were uncovered more than three thousand years later by the archaeological team of Theodore M. Davis.

This story is told in the following essay by Herbert E. Winlock, first published by The Metropolitan Museum of Art in 1941 as *Materials Used at the Embalming of King Tūt-'ankh-Amūn*, number 10 in a series of "Papers." Here illustrated with new photography, Winlock's text will surely captivate readers once again. Winlock (1884–1950) was educated at Harvard and began his thirty-year career with the Metropolitan Museum as a member of the Museum's Egyptian Expedition at Lisht, about thirty miles south of present-day Cairo. Assisting Albert M. Lythgoe, the Metropolitan's first curator of Egyptian art, and associate curator Arthur Mace, Winlock soon showed his singular abilities as an excavator and interpreter of the past. In 1911 he became field director of the Museum's excavations at Thebes, where he made a number of highly important discoveries, and in 1928 he succeeded Lythgoe as head of the Department of Egyptian Art; he was named director of the Museum in 1932. After retiring from that post seven years later, he continued to write about his finds.

Davis (1837–1915) was quite a different character. One of a dying breed of amateur archaeologists, Davis was a retired New York City lawyer who, between 1902 and 1914, devoted much of his time to excavations in the Valley of the Kings. He received help from a

FIG. 10 King Aya performs the "Opening of the Mouth" ritual for Tutankhamun, here depicted in the shape of the god Osiris. Detail of a painting on the north wall of Tutankhamun's burial chamber

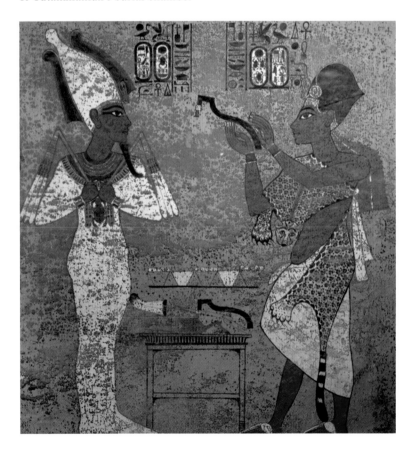

series of young Egyptologists, among them Howard Carter, then Inspector of Monuments in Upper Egypt, and photographer Harry Burton; Edward R. Ayrton was the archaeologist employed on the 1907–8 dig. Davis's excavation methods were rather rough, but they were not much worse than those of some professional excavators working in Egypt in the early twentieth century. His lasting legacy lies not only in his discoveries but also in the magnificently produced volumes he published about his finds. Graced with photographs by Burton and others, they are indispensable even today to any study of the tombs in the Valley of the Kings.

At the time of these expeditions, the Egyptian government allowed a fifty-fifty partition of finds between foreign excavators and the Egyptian Museum in Cairo, with the most valuable objects reserved for the latter. Davis bequeathed much of his half—including items from the famous tomb of Yuya and Tuya (KV 46), possibly Tutankhamun's great-grandparents; and burial equipment of the Amarna royal family, such as that of Queen Tiye (KV 55), who was most likely Tutankhamun's grandmother—to The Metropolitan Museum of Art. However, as he considered the group of objects that form the subject of the present book to be something of a disappointment, he donated them almost immediately to the Museum.

In Winlock's narrative, Davis does not appear to advantage in what he allowed to happen to the objects he had excavated. This is certainly not the only time that ignorance has led to the contempt and destruction of objects and monuments from the past, and it points to the importance of the Socratic principle that we should "know that we do not know." Archaeologists must always be respectful of what has yet to be explained. In the case presented here, archaeology was fortunate to have Herbert Winlock as a witness. His superior knowledge eventually provided an explanation for a find that has intrigued scholars and enthusiasts of ancient Egypt ever since.[13]

The photographs in this volume are accompanied by revised captions, but the original 1941 paper is reprinted here without alteration, except for minor stylistic changes. Yet, as this introduction makes clear, archaeologists have learned considerably more about Tutankhamun's era in the intervening years. Even now, archaeologists are studying the recently discovered embalming cache mentioned above. Thus, sections where Winlock's analysis has been supplemented or reassessed are marked with an asterisk and are taken up in the appendix entitled "Updating Winlock," which follows his essay. None of this scholarly apparatus should, however, diminish the reader's joy in encountering one of Egyptology's canonical texts.

1 Herodotus, the Greek historian of the fifth century B.C., gives a period of seventy days for the embalmment process, but the length of time appears to have varied. Genesis 50:1–3 records that the embalmment of Jacob took forty days. For a description of the mummification procedure and its various types, see Salima Ikram and Aidan Dodson, *The Mummy in Ancient Egypt: Equipping the Dead for Eternity* (London, 1998), pp. 103–36; John H. Taylor, *Death and Afterlife in Ancient Egypt* (London, 2001), pp. 46–91.

2 Translation by Raymond O. Faulkner, in his *The Ancient Egyptian Coffin Texts*, 3 vols. (Warminster, 1973), vol. 1, p. 11. It was identified as a ritual text recited during mummification by Jan Assmann; see Assmann, *Altägyptische Totenliturgien*, 3 vols. (Heidelberg, 2002), vol. 1: *Totenliturgien in den Sargtexten des Mittleren Reiches*, pp. 121–22.

3 Horst Beinlich, "Zwischen Tod und Grab: Tutanchamun und das Begräbnisritual," *Studien zur altägyptischen Kultur* 34, 2006, pp. 17–31. Harold M. Hays, "Funerary Rituals (Pharaonic Period)," 2010, in *UCLA Encyclopedia of Egyptology*, edited by Jacco Dieleman, Willeke Wendrich (Los Angeles, ongoing), p. 6. Online at http://www.escholarship.org/uc/item/lr32g9zn.

4 Siegfried Schott, *Das schöne Fest vom Wüstental: Festbräuche einer Totenstadt*, Abhandlungen der Geistes und Sozialwissenschaftlichen Klasse, no. 11, Akademie der Wissenschaften und Literatur, Mainz, Jahrgang 1952 (Wiesbaden, 1953).

5 Geoffrey T. Martin, *The Memphite Tomb of Horemheb, Commander-in-Chief of Tut'ankhamūn*, vol. I: *Reliefs, Inscriptions, and Commentary* (London, 1989), pp. 100–3, pls. 120–24.

6 Jacobus van Dijk, "Zerbrechen der roten Töpfe," *Lexikon der Ägyptologie*, edited by Wolfgang Helck and Wolfhart Westendorf, 7 vols. (Wiesbaden, 1986), vol. 6, cols. 1389–96.

7 Christine Beinlich-Seeber and Abdel Ghaffar Shedid, *Das Grab des Userhat (TT 56)* (Mainz, 1987), pp. 93–94.

8 Beatrix Gessler-Löhr, "Exkurs: Die Totenfeier im Garten," in *Das Grab des Amenemope TT 41*, edited by Jan Assmann (Mainz, 1991), pp. 162–83; Heike Guksch, *Die Gräber des Nacht-Min und des Men-cheper-Ra-seneb Theben Nr. 87 und 79* (Mainz, 1995), pp. 62–68.

9 Mortuary temples were built by the pharaohs for the daily celebration of their cult after death as well as the worship of Amun, the supreme god of Thebes, and other deities. Archaeologists have long believed that Tutankhamun's temple was located close to where the temple of Ramesses III still stands, at Medinet Habu. But this has been put into doubt most recently by Marianne Eaton-Krauss, in her "The Burial of Tutankhamen, Part One," *KMT, A Modern Journal of Ancient Egypt*, vol. 20, no. 4 (Winter 2009–10), pp. 36–38.

10 Marianne Eaton-Krauss, "The Burial of Tutankhamen, Part Two," *KMT, A Modern Journal of Ancient Egypt*, vol. 21, no. 1 (Spring 2010), pp. 19–36.

11 Susan Allen, "Tutankhamun's Embalming Cache Reconsidered," in *Egyptology at the Dawn of the Twenty-First Century: Proceedings of the Eighth International Congress of Egyptologists, Cairo, 2000*, edited by Zahi Hawass and Lyla Pinch Brock, 3 vols. (Cairo, 2003), vol. 1, p. 24. Although Winlock discovered more embalming caches in the 1920s, these were all outside the Valley of the Kings and related to nonroyal burials; thus, they were not considered convincing evidence.

12 For more on KV 63, see Otto Schaden, "The Amenmesse Project, Season 2006," *Annales du Service des Antiquités de l'Égypte* 82 (2008), pp. 231–60; Schaden, "KV63 Season 2009," *KMT, A Modern Journal of Ancient Egypt*, vol. 20, no. 3 (Fall 2009), pp. 19–29; and the website http://www.kv-63.com. See also Marc Gabolde, "Some Remarks on the Embalming Caches in the Royal Necropolis at Thebes and Amarna," lecture at the symposium "The Valley of the Kings after Howard Carter," hosted by Zahi Hawass and the Supreme Council of Antiquities of Egypt, Luxor, fall 2009. I thank Dr. Gabolde for making a copy of his paper available to me.

13 Davis's excavations and Winlock's analysis also paved the way for the later discovery of Tutankhamun's tomb. As Howard Carter and Arthur Mace wrote in the first volume of *The Tomb of Tut·Ankh·Amen Discovered by the Late Earl of Carnarvon and Howard Carter* (London, 1923), pp. 77–78:

"[A]t the risk of being accused of *post actum* prescience, I will state that we had definite hopes of finding the tomb of one particular king, and that king Tut·ankh·Amen.

To explain the reasons for this belief of ours we must turn to the published pages of Mr. Davis's excavations. Towards the end of his work in The Valley he had found, hidden under a rock, a faience cup which bore the name of Tut·ankh·Amen. In the same region he came upon a small pit-tomb, in which were found an unnamed alabaster statuette, possibly of Ay, and a broken wooden box, in which were fragments of gold foil, bearing the figures and names of Tut·ankh·Amen and his queen. . . .

Some little distance eastward from this tomb, he had also found in one of his earlier years of work (1907–8), buried in an irregular hole cut in the side of the rock, a cache of large pottery jars. . . . A cursory examination was made of their contents, and as these seemed to consist merely of broken pottery, bundles of linen, and other oddments, Mr. Davis refused to be interested in them, and they were laid aside and stacked away in the store-room of his Valley house. There, some while afterwards, Mr. Winlock noticed them, and immediately realized their importance. With Mr. Davis's consent the entire collection of jars was packed and sent to the Metropolitan Museum of Art, New York, and there Mr. Winlock made a thorough examination of their contents. Extraordinarily interesting they proved to be. . . . [T]he whole representing, apparently, the material which had been used during the funeral ceremonies of Tut·ankh·Amen, and afterwards gathered together and stacked away within the jars.

We had thus three distinct pieces of evidence . . . which seemed definitely to connect Tut·ankh·Amen with this particular part of The Valley."

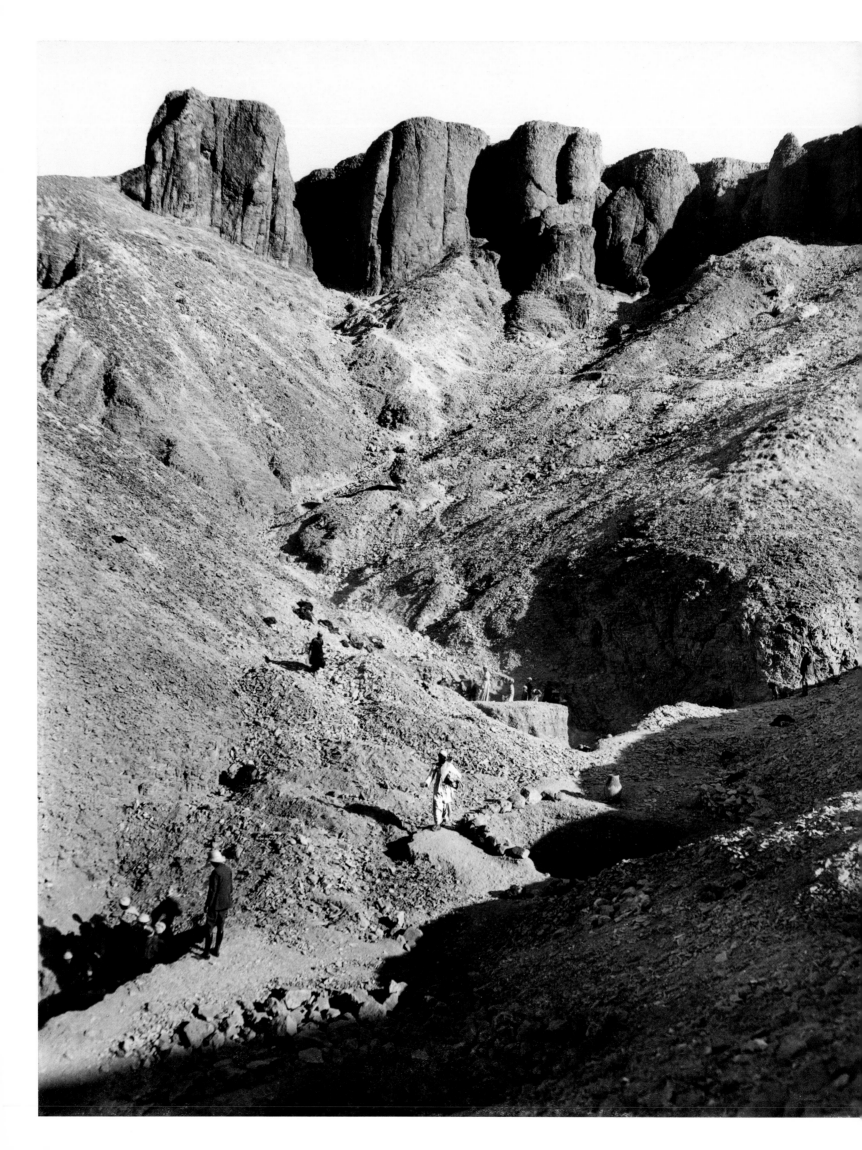

Materials used at the embalming of king tutankhamun

Herbert E. Winlock

There was an event that happened in Egypt when I was living there that I think I ought to put down on paper. I have talked to people about it, but I am afraid that many of those who were once my listeners are long since dead and that everybody else who has heard this tale will be soon. It is the story of how Theodore M. Davis once upon a time found the things that had been used at the funeral of King Tutankhamun in 1360 B.C.[1]* A quarter of a century ago no one associated this material with the king's tomb, and some old notes of mine tell of all the finders being dead within nine years of the excavations.

Sometime early in January 1908,* I spent two or three days with Edward Ayrton, to see his work for Mr. Davis in the Valley of the Kings. When I got to the house (figs. 12, 13) the front "lawn" had about a dozen gigantic white pots lying on it where the men had placed them when they brought them from the work. At that time Ayrton had finished a dig up in the Valley of the Kings just east of the tomb of Ramesses XI (no. 18).* He had quite a job on his hands to find something to amuse Sir Eldon Gorst, the British diplomatic agent who was to be Mr. Davis's self-invited guest soon. Sir Eldon had written a very strange little note, which I saw, saying to Mr. Davis that he had heard that the latter's men found a royal tomb every winter and requesting, as he intended to be in the Valley of the Kings in a few days, that all discoveries be postponed until his arrival. This event was going to take place on Friday, January 17, when everything had to be spick and span and something had to be opened for him. Davis had found the jewelry of Queen Tawosret in another tomb, but that was not sufficiently spectacular, and as he had opened one of the great pots and found a charming little yellow mask* in it, everybody thought they were going to find many more objects in the other jars.

PREVIOUS PAGE
FIG. 11 Theodore Davis (standing in foreground) supervises excavation work in the Valley of the Kings, 1909–10. Photograph by Harry Burton (MMA neg. no. T 31336 dup.)

I had to disappear the day Sir Eldon came, and so I lunched with Howard Carter and Erskine Nichol in the Medinet Habu house where they were doing watercolors. I think it was that afternoon that I first saw how the two of them put in their skies upside down so as to have the paint run at its darkest at the top of the picture. That evening I walked back over the hills to the Davis house in the Valley, and I have still got a picture in the back of my head of what things looked like. What in the morning had been fairly neat rows of pots were tumbled in every direction, with little bundles of natron and broken pottery all over the ground. The little mask which had been taken as a harbinger of something better to come had brought forth nothing, and poor Ayrton was a very sick and tired person after

FIG. 12 The entrance to the Western Valley, 1912 or earlier. The house of Theodore Davis can be seen in the background. Photograph by Harry Burton (MMA neg. no. T 3122)

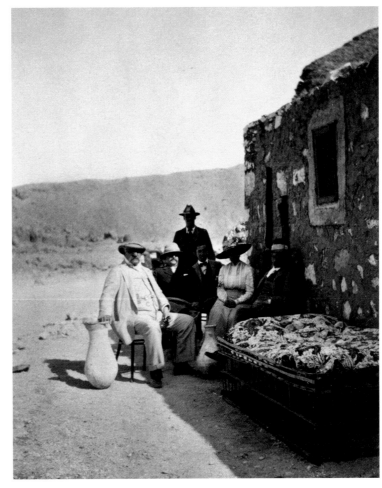

FIG. 13 In front of Davis's house in 1911 (left to right): Metropolitan Museum president J. Pierpont Morgan, unidentified man, Herbert Winlock (standing), Harry Burton, unidentified woman, and Theodore Davis. Morgan holds a large pot possibly from the tomb of Yuya and Tuya (KV 46). (MMA neg. no. MM 79544)

the undeserved tongue-lashing he had had all that afternoon. Sir Eldon complimented Mr. Davis on his cook, and that is the last of him as far as this story is concerned.

All the jars and their contents were eventually stowed in a magazine of the house in the Valley. Mr. Davis used to demonstrate how strong papyrus could be after over thirty centuries by pulling and tearing apart with his guests bits found in the jars, but he had no other use for the find. In fact, it was rather in the way, and Harold Jones, who had been with us on our work at Lisht but had taken Ayrton's place in charge of Mr. Davis's excavations in the Valley in 1908–9, persuaded him to get Sir Gaston Maspero to look at the objects and to let the then struggling Metropolitan Museum have everything it wanted from the find. Therefore I was in Mr. Davis's house in the Valley again in the spring of 1909, packing up such pots and pans and such rags and little bags of natron as were around his magazine for the Museum in New York. When they got there they were all laid out in one of the unopened Egyptian galleries, sorted, and entered in the catalogue.[2]*

The objects found by Theodore Davis had been buried by the ancient Egyptians in a little pit, today called no. 54,* only 110 meters southeast of the mouth of the tomb where Tutankhamun's body had been put (figs. 14, 15). It was on the south side of the eastern branch of the Valley of the Kings, in a spot totally deserted in those days. Here on the hillside the undertakers had dug through the gravel into the bedrock to make a pit 1.90 meters long and 1.25 meters wide, which they oriented almost exactly north and south (fig. 16). Twenty-five years ago it was still 1.40 meters deep at the south, uphill end and only 1.00 meter at the north end. The rock at that time was covered with a heap of chip over three meters high, but it seems probable that when the pit was cut there was only a meter of loose stone and gravel lying on the surface and that the pit originally was dug two meters deep. The rest of the chip in this neighborhood was probably thrown out during the construction of some nearby tomb, perhaps that of Ramesses VI.

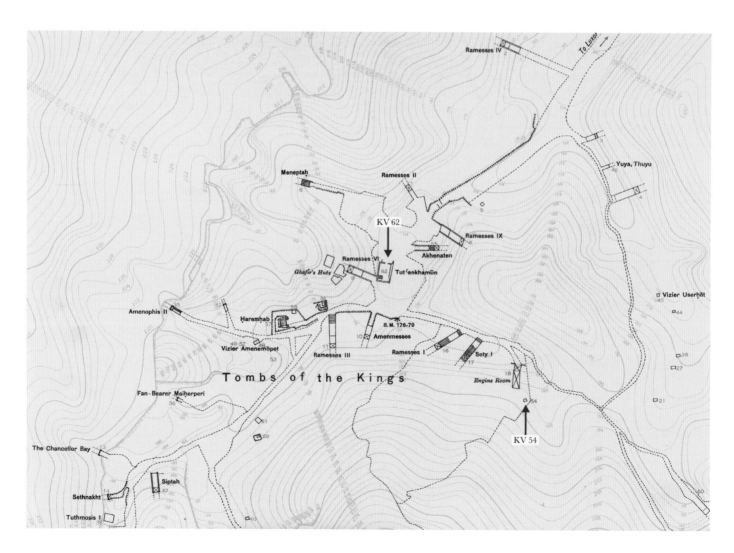

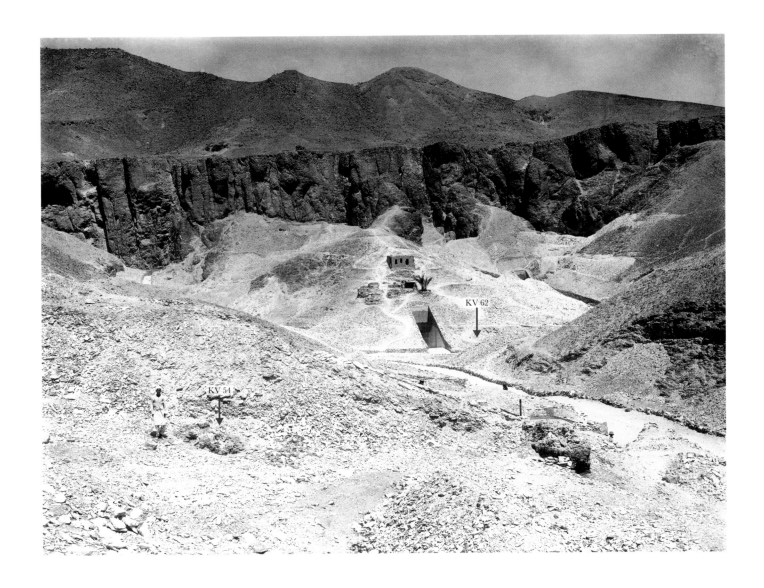

FIG. 14 Detail of a Survey of Egypt map from the 1920s, showing the Valley of the Kings area around Tutankhamun's tomb (KV 62) and embalming cache (KV 54)

ABOVE
FIG. 15 Left: Tutankhamun's embalming cache (KV 54), with the tomb of Ramesses VI in the background; the tomb of Tutankhamun (KV 62) had yet to be excavated. Photograph by MMA Egyptian Expedition, undated (MMA neg. no. M 3556)

RIGHT
FIG. 16 KV 54 after the materials had been removed, 1909. Photograph by Harry Burton (MMA neg. no. T 348)

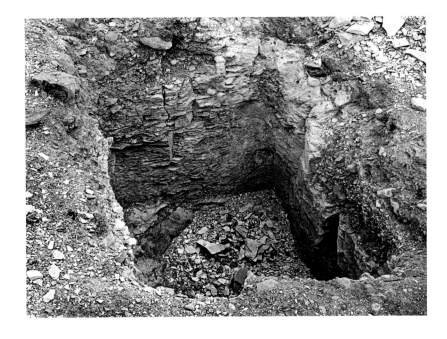

No one knows actually how many big pots Theodore Davis found, but about a dozen of the size and shape of the ones taken to his house could have been crowded into the pit. They had been brought up to the Valley, doubtless, in rope slings[3]—of which, however, no trace was found—and neatly piled in the hole in regular rows. When I saw them many were broken, but from the description I had at the time there must have been at least twelve, or possibly fifteen, of them, all exactly alike. Six are preserved in the Metropolitan Museum (fig. 17, right).[4] Of these the average height is 71 centimeters, the diameter at the mouth 35 centimeters, and the greatest diameter of the body 46.5 centimeters. They are made of a hard, resonant, light red clay. There are no inscriptions on them. The contents and the packing material came to within a few centimeters of the rim. In each case a layer of Nile mud had been smeared over all, and a layer of white lime and sand plaster poured on until it was flush with the top; this had been smoothed neatly, and the whole pot then whitewashed. An irregular spot on the outside of each of the pots at the very bottom did not get any coloring, and one of the pots had contained some wet material which leaked out through the top, leaving a brown stain. This type of pot is characteristic of the late Eighteenth Dynasty. We may take them as typical storage jars of that period, a little smaller than those in the story of Ali Baba but otherwise much the same.

The pots contained embalming materials and objects from the funerary banquet of King Tutankhamun,* piously collected and packed in clean wheat or barley chaff[5]—which had only turned brown and was very little disintegrated. The objects found were in excellent preservation.

No one in the Theodore Davis camp knew exactly what this mass of material was. Mr. Davis himself seems to have felt that he had discovered the contents of a poor man's tomb, and since there was no mummy there and manifestly he was the first to have seen the pit, he thought all the objects had been moved to it by the necropolis guardians.[6] What he had actually found, of course, was a cache of materials which, according to Egyptian beliefs, were too impure to be buried in the tomb with the dead man but which had to be safely put not far away from his body, since the latter had been in contact with them. It was a perfectly undisturbed cache which Mr. Davis found, but in some fashion it became confused in his mind with a faience cup bearing King Tutankhamun's name and some gold leaf from objects made by King Aya for King Tutankhamun's tomb. Although these objects may have been stolen from the tomb by the thieves who we know had got into it for a short time, and had been carried away and hidden in deserted sepulchers nearby, they could have had no real relation to this find.

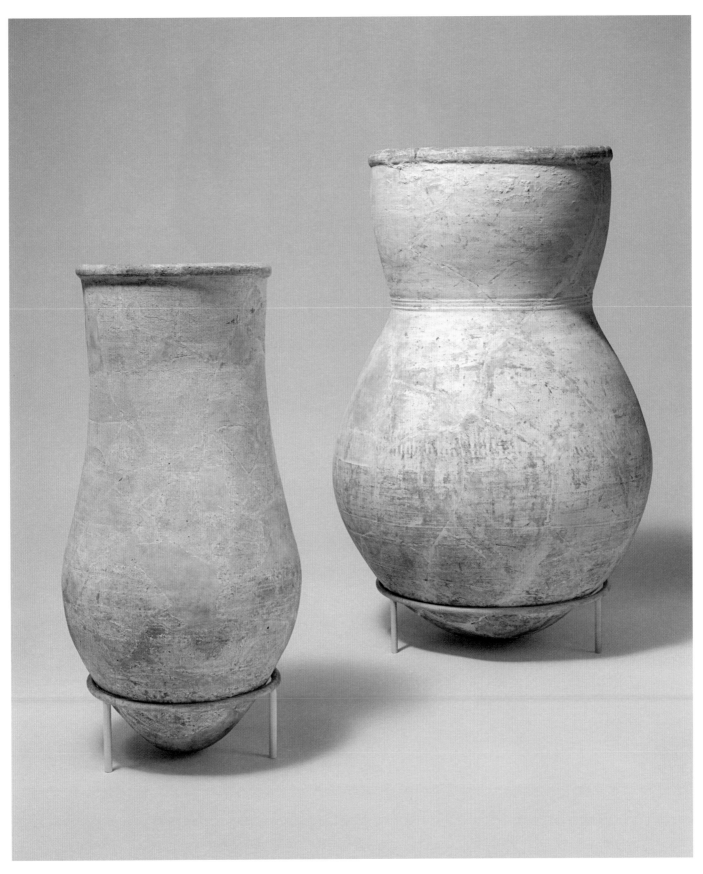

FIG. 17 Pottery vessel and large container. Left: h. 56.3 cm (22³/₁₆ in.); right: h. 71 cm (28 in.).
The Metropolitan Museum of Art, New York; Gift of Theodore M. Davis, 1909 (09.184.8, 09.184.1)

FIGS. 18A–B Mud seal with impression of the name Tutankhamun and the epithet "[beloved of] Ptah," front and side views. L. 3 cm (1⅛ in.). The Metropolitan Museum of Art, New York; Gift of Theodore M. Davis, 1909 (09.184.260)

At first we were all inclined to agree with Mr. Davis. Everything looked as though it had seen hard usage, and none of us was as familiar with embalmers' caches in 1908 as we might have been. But in the early 1920s I had found so many earlier and later masses of such materials* that I began to realize what Theodore Davis had discovered—obviously fragments of embalming materials and scraps from the funeral meal of King Tutankhamun.

The evidence for the date is clear. In the first place, there are six mud impressions of ring or scarab seals,* broken from tomb furniture (figs. 18–22; 76, B–E).[7] D appears to have been wrenched off a box or some other straight-sided object and has on the back the impressions of a thick grass cord and of linen cloth (figs. 18a–b). B and C are still attached to knotted strips of thick papyrus fiber (figs. 19a–b, 20a–b). E again has the impression of a thick cord such as might have been used on a chest (figs. 21a–b). D bears distinctly the cartouche of Tutankhamun, and B and C give his throne name. It seems clear that the epithets ☰🜊, "beloved of Khnum," and 𓎛𓏏𓏥, "of manifold praises,"[8] must qualify a royal name, here written ☉🜨𓏼[◡], with the sign *neb* broken away. The fourth seal, E, is that of the priests of the necropolis of the Valley of the Kings—the jackal above the nine bound captives.[9] The fifth is the impression of one of those faience rings or scaraboids so popular at the period, with the device 🜊𓏺 (fig. 22). The sixth is illegible.* Five little pats of dried mud,[10] averaging

28

FIGS. 19A–B Mud seal with impression of the throne name of Tutankhamun, Nebkheperure, and the epithets "beloved of Khnum" and "manifold of praises," front and back views. L. 2.5 cm (1 in.), not including papyrus tie. The Metropolitan Museum of Art, New York; Gift of Theodore M. Davis, 1909 (09.184.262)

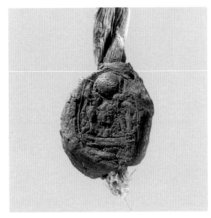

FIGS. 20A–B Mud seal with same impression as fig. 19, front and back views. L. 2.5 cm (1 in.), not including papyrus tie. The Metropolitan Museum of Art, New York; Gift of Theodore M. Davis, 1909 (09.184.263)

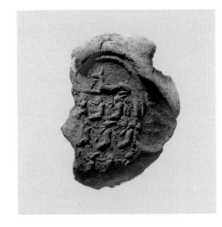

FIGS. 21A–B Mud seal with impression of the seal of the necropolis, showing the jackal of Anubis above nine foreign captives, front and back views. L. 2.5 cm (1 in.). The Metropolitan Museum of Art, New York; Gift of Theodore M. Davis, 1909 (09.184.261)

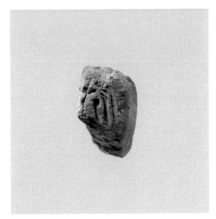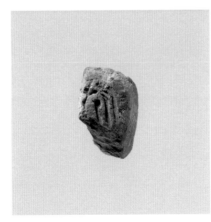

FIGS. 22A–B Mud seal with impression of beneficial device, front and back views. L. 1.5 cm (⅝ in.). The Metropolitan Museum of Art, New York; Gift of Theodore M. Davis, 1909 (09.184.265)

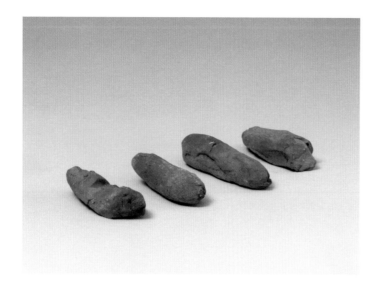

FIG. 23 Finger-shaped pieces of dried mud, probably for use as sealing pads. L. 6.7–7.9 cm (2⅝–3⅛ in.). The Metropolitan Museum of Art, New York; Gift of Theodore M. Davis, 1909 (09.184.235b–e)

about 7 by 2.5 centimeters, were probably left over from sealing articles which went into the tomb of Tutankhamun, where many sealed objects were found (fig. 23).

Furthermore, the date of the objects in the cache was toward the end of the reign of Tutankhamun. One piece of linen cloth from the pots is marked Year 6 of his reign (figs. 24; 77, A).[11] It has been the subject of articles by Maspero, by Davis, by Daressy, and by Lythgoe.[12] This piece of fringed linen sheet, somewhat crumpled up, has an inscription in one corner written from right to left in cursive hieroglyphs and reading*: "The Good God, Lord of the Two Lands, Nebkheperure, beloved of Min; linen of Year 6" (fig. 24a). Its length, 94 centimeters, is the original length of the sheet, but its original width is indeterminable, since it is now ripped down to 32 centimeters. The cloth is of medium texture, with seventeen warp threads and twenty-two woof threads to the centimeter.* A fringe of 1.5 centimeters wide is woven into the top (fig. 24b).* One end has a selvage* and the other a selvage partly raveled out, as though for fringing.* About 25 centimeters from the fringed top and roughly midway between the two ends of the sheet there are what might be taken for parts of two lines of hieratic, written at right angles to the first inscription (fig. 24c). In color these two lines are blue-black—as are some stains near the hieroglyphs above—while the marks in the corner of the sheet and those on another inscribed sheet (see below) are in a very deep brown-black ink. There has been considerable discussion in the Metropolitan Museum as to whether or not these blue-black stains are writing. On the whole, my final conclusion is that they are probably not; but if they are, there is too little left for any intelligible translation.

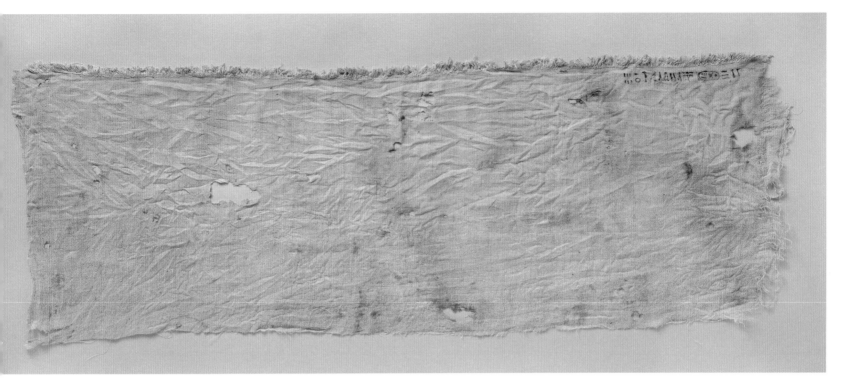

FIG. 24 Piece of linen cloth marked "Year 6" of Tutankhamun's reign (ca. 1331 B.C.)
in the upper right corner. L. 96.5 cm (38 in.), w. 35.3 cm (13 7/8 in.). The Metropolitan Museum
of Art, New York; Gift of Theodore M. Davis, 1909 (09.184.220)

FIG. 24A Piece of linen cloth, detail of fig. 24, showing the ink inscription in the upper right corner

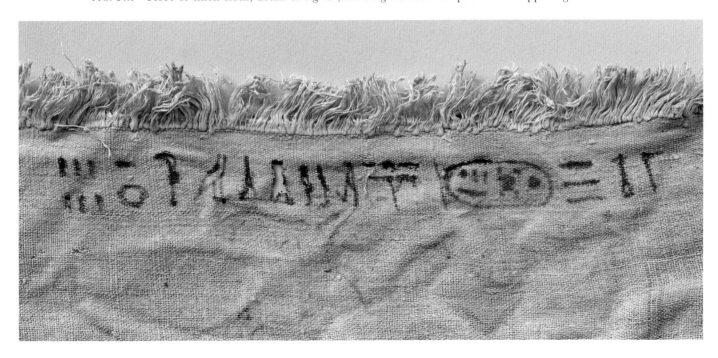

FIG. 24B Piece of linen cloth, detail of fig. 24 (top left corner), showing the weft fringe and headings

FIG. 24C Piece of linen cloth, detail of fig. 24 (bottom center), showing a possible hieratic inscription

Of even greater importance is a large piece of sheet 2.44 meters long and 61 centimeters wide (figs. 25; 77, B).[13] Its length is the original length of the sheet, for one end is rolled and hemmed and the other shows traces of a selvage.* The original width cannot be determined, for a piece has been ripped off each side. The sheet is of very fine, tightly woven but not heavy linen, with thirty-six warp threads and twenty-eight woof threads to the centimeter.* Though badly worn and stained in antiquity and afterward very much decayed, it has a date upon it which was written not more than a year before it was put into the pit.

The marks are among the most curious I have ever seen. Three centimeters from the selvage end and 13 centimeters from a torn side, which was probably originally fringed, occurs a mark woven into the material and reading: "Long live the Good King Nofer." The signs are in white thread, the same color as the cloth itself, but, being a somewhat tighter weave, they are quite legible (fig. 25a).*

On the opposite side of the cloth from which one is supposed to read the woven mark, but in the same corner, is the usual type of ink linen mark. The tear along the side runs through the inscription, but originally it seems to have read: "Year 8. Amun-Re. Very good." The sheet was washed at least once after the marking, and the ink is now very brown (fig. 25b).

The third inscription was written after the fringe had been removed, on the same side as the ink linen mark above, 2.5 centimeters below the torn side and some 9 centimeters from the selvage end* but in no wise parallel to it. It reads: "Year 8 of the Lord of Two Lands,

Nebkheperure," and it is followed at a distance of 2 centimeters to the left by a private mark of some sort, undoubtedly of the same period (fig. 25c). On the opposite side of the cloth and 15 centimeters from the other, hemmed end* are two crosses, written in ink and of the same period as the third group (fig. 25d).

Both dates in these inscriptions are the same, and it is interesting that one was written while the sheet still had a fringe and the other sometime after the sheet had been washed and the fringe torn off. The eighth year of Tutankhamun's reign was probably the next to last year of his life.

FIG. 25 Linen sheet with ink writing. L. 2.51 m (98 7/8 in.), w. 62 cm (24 1/2 in.). The Metropolitan Museum of Art, New York; Gift of Theodore M. Davis, 1909 (09.184.693)

When the floor was swept after wrapping the body of a king, naturally there were quantities of pieces of linen —some of them bandages and some wider bits—gathered up. In addition to the inscribed pieces already mentioned, a great many scraps of linen, the leftovers of the wrapping of the mummy of Tutankhamun, were stuffed away in the jars. Carter and Lucas, in *The Tomb of Tut·ankh·Amen*, have mentioned how completely the bandages on the mummy had become carbonized,[14] and we must consider ourselves fortunate in possessing these scraps torn from the bandages at the time of the king's wrapping.

Usually bandages to be wound on a body were rolled up to make the wrapping easier. The ends of some six such bandages still remain.[15] All are of fine linen cloth, and still so tightly rolled that we have not wanted to undo them. In width the narrowest is 2.5 centimeters and the widest 12.5 centimeters.

The majority of the bandages have one or both ends torn off and so could have been ripped from sheets of any length. At least 180 were found in the big pots, and these vary from 15 centimeters to 15 meters in length and from 1 centimeter to 15 centimeters in width.[16]

FIG. 25A Linen sheet, detail of fig. 25, showing woven inscription

FIG. 25B Linen sheet, detail of fig. 25, showing ink inscription, partly torn and faded from washing, mentioning "Year 8" of Tutankhamun's reign (ca. 1329 B.C.) and identifying the quality of the sheet as "very good"

FIG. 25C Linen sheet, detail of fig. 25, showing inscription mentioning "Year 8" of Tutankhamun's reign (ca. 1329 B.C.), written after the sheet was washed; illegible mark at left

FIG. 25D Linen sheet, detail of fig. 25, showing two crosses (possibly identifying an inspection by a supervising official) written after the sheet was washed

About two dozen pieces of cloth, from 1 to 6 centimeters wide, have fringe varying from 1 to 11 centimeters in length along the selvage edge, and now and then there is a scrap with the warp threads also made into fringe, occasionally 13 centimeters long (fig. 28).[17] Some of the pieces are only 6.5 centimeters long, some are as much as 4.55 meters long, and others almost every conceivable length in between. One very heavy braided fringe about 38 centimeters long, with each braid at least 5 millimeters in diameter, had caught in something and been ripped back about four or five centimeters,[18] but it had been repaired by tying the two adjacent braids together. On another strip of very much finer material with a smaller fringe the same repair had been made in the same way.[19] This piece of cloth, like several others, had double woof threads woven in at a distance of 1.5 centimeters from the fringe end—an effective stop to deeper tearing. Sometimes the embalmers had ripped fringes or edges from the sheets to make wide smooth bandages, and all these scraps were carefully swept together and put away in the jars.[20]

Four bits which measure from 1.5 to 3.5 centimeters wide and from 14.5 to 26 centimeters long had been dyed pink before they were ripped into bandages (figs. 26, 27).[21]

FIG. 26 Rolled bandage from a linen sheet dyed red. Formerly in the collection of The Metropolitan Museum of Art, New York (09.184.577)

FIG. 27 Bandage ripped from a fringed sheet of linen. Formerly in the collection of The Metropolitan Museum of Art, New York (09.184.643)

FIG. 28 Bandage, ripped from a linen sheet with long fringe. The tearing mentioned by Winlock is not visible in the only available photograph. Formerly in the collection of The Metropolitan Museum of Art, New York (09.184.663a, b)

FIG. 29 Bundle of cloth used as a broom. Formerly in the collection of The Metropolitan Museum of Art, New York (09.184.653)

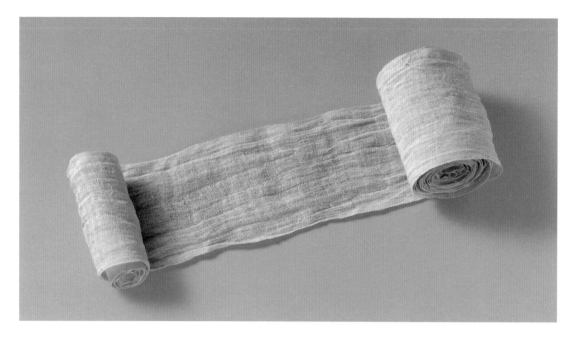

FIG. 30 Narrow woven linen tape for use as mummification bandage. L. 164 cm (64 5/8 in.), w. 5.5 cm (2 1/8 in.). The Metropolitan Museum of Art, New York; Gift of Theodore M. Davis, 1909 (09.184.797)

For the rest, there are twenty-six wide pieces, all ripped from linens of different size and texture.[22] One is from a shirt, with half of the neck opening still outlined by its hem. These pieces are the wipers from the embalming shop and frequently bear obvious traces of their use.

One of the most curious things among the bandages are fifty pieces of narrow tape with a selvage on each side (fig. 30).[23] I do not recall ever having seen any ready-made, Eighteenth Dynasty bandages like them before. Their widths run from 1.8 centimeters to 11 centimeters. The lengths to which they were woven cannot be determined because in every case both ends are torn off, but the longest is 4.70 meters long and the shortest a mere scrap 39 centimeters long.* Some half dozen pieces had been in contact with salt and are still white, but the majority have turned to a brown of varying darkness. They are usually very clean, but now and then one can see fingerprints where someone had wiped his hands on them. I can conceive of no use for these strips except as bandages. They must have been expensive—old, ripped sheets would have been far cheaper—and this probably explains why there were only these fifty among the hundreds of bandages used on the body.

There are also two tightly wound-up bundles, one a ball of very fine linen wadded up to make just a small handful[24] and the other a tightly wrapped bundle, folded in the middle, the ends of which were used like a broom to sweep up dirt until the cloth itself was worn away to a length of only 8.5 centimeters (fig. 29).[25]

Among the pile of rags from the jars three are of especial interest.[26] These are kerchiefs,* two of white and one of blue linen of double thickness, with the edges turned in and sewed over and over (figs. 31–33).* Such kerchiefs must have been worn over wigs as a protection from the dust, quantities of which must have been blowing around all the time. All three had seen a good deal of use and had been washed so often that the edges had begun to come unsewed. The two white ones have worn spots on the forehead, particularly inside, and had been darned anciently.* The blue one had been used as some sort of scrubbing rag, so that it was worn all the way through in the middle and the tapes were completely destroyed. The front of each kerchief is a straight edge and the back rounded; a tape some 92 centimeters long* and about 1.5 centimeters wide, with free ends about 25 centimeters long, is sewed across the forehead 12 centimeters from the two corners.

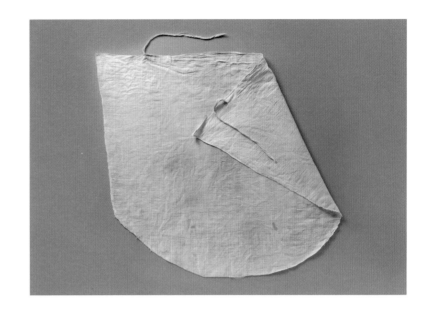

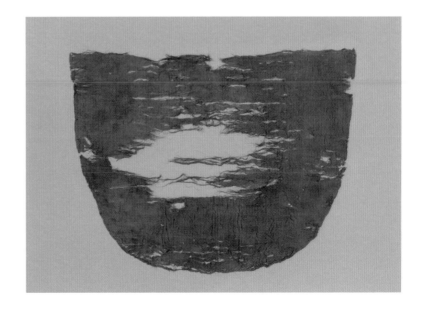

FIG. 31 Kerchief. The tape is sewn into a narrow pocket along the front edge, between the two layers of linen. L. 52.5 cm (20⅝ in.), w. 68.5 cm (27 in.). The Metropolitan Museum of Art, New York; Gift of Theodore M. Davis, 1909 (09.184.219)

FIG. 32 Kerchief. Note the creases along the two upper corners, indicating that they were tucked in when the piece was worn. Linen, l. 51 cm (20⅛ in.), w. 66 cm (26 in.). The Metropolitan Museum of Art, New York; Gift of Theodore M. Davis, 1909 (09.184.218)

FIG. 33 Blue kerchief. Linen dyed with indigotin, l. 40 cm (15¾ in.), w. 53 cm (20⅞ in.). The Metropolitan Museum of Art, New York; Gift of Theodore M. Davis, 1909 (09.184.217)

FIG. 33A Blue kerchief, detail of fig. 33, showing small knots in a vertical row on the right side

FIG. 33B Blue kerchief, detail of fig. 33, showing stitching along the edge joining the two layers of linen

FIG. 33C Blue kerchief, detail of fig. 33, showing darning at upper right

The lengths from the middle of the forehead to the middle of the semicircular back are 40, 51, and 52.5 centimeters, and the widths in front are 53, 66, and 68.5 centimeters—the blue kerchief being the smallest. All three kerchiefs are made of very light and fine linen; in two cases the threads number thirty by sixty to the square centimeter, and in the third there are as many as thirty-five by seventy-five.* The dye used for the blue one was probably the juice of the *sunt* berry (*Acacia nilotica*).*

When being put on, the front of these kerchiefs was probably held between the forefinger and thumb of each hand while the back was thrown up over the head, and the tapes were then carried back under the kerchief and tied. In this way they would cover any short wig effectively. Such kerchiefs must have been common around Thebes at the time they were made.

Unfortunately, we can never have an accurate count of the bags of chaff* and salt found in the large pots. Some of these bags have been lost, for I distinctly remember that we did not bring them all home. The count of them given here, therefore, is necessarily short by at least a half and perhaps more.

Today there remain some two dozen bags filled with natron—the combination of soda and salt so essential to every Egyptian embalmer.[27] In size the bundles run from 20 centimeters square and 7 centimeters thick, the largest, down to an occasional one 6 centimeters square and 3 centimeters thick. Their makers simply took a square of linen and filled it with natron, then gathered together the four corners, twisted them tightly, and wrapped them round and tied them with a narrow strip of linen (figs. 34a–c).

At least as numerous are bags of more uniform size containing chaff.[28] They run from about 8 to 10 centimeters square and from 3 to 5 centimeters thick, with one large one some 15 centimeters in diameter. They contain mainly chopped straw, which has such a salty taste today that one is led to believe that the mixture was intentional, and now and then one finds that the quantity of salt is so great that it is hard to separate this class of bag from the first (fig. 35).

We also found at least five long cloth cylinders, sewed at one end and up one side and, after being filled, tied at the other end with a cord.[29] Curiously enough, the longest is also the thinnest, being 100 centimeters in length and only 2 centimeters in diameter. Two others, measuring 85 centimeters and 75 centimeters in length, are 4 centimeters in diameter. All are packed with a very fine natron. Their use is somewhat difficult to imagine, since none was found half emptied and none showed any signs of soiling (fig. 36).*

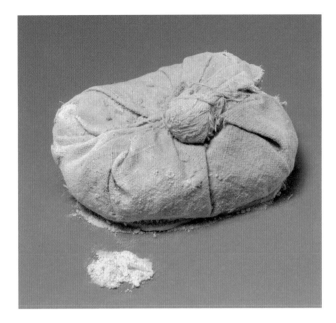

FIG. 34A Linen bag filled with natron and some loose natron. Diam. 8.5 cm (3³⁄₈ in.). The Metropolitan Museum of Art, New York; Gift of Theodore M. Davis, 1909; Deaccessioned, 1957; Gift of Joseph Veach Noble, 1988

FIG. 34B Linen bag filled with natron. Formerly in the collection of The Metropolitan Museum of Art, New York (09.184.228)

FIG. 34C Linen bag filled with natron. Formerly in the collection of The Metropolitan Museum of Art, New York (09.184.230)

FIG. 35 Linen bag filled with chaff. Formerly in the collection of The Metropolitan Museum of Art, New York (09.184.232)

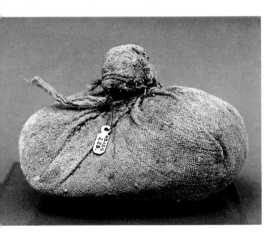

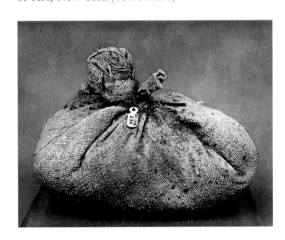

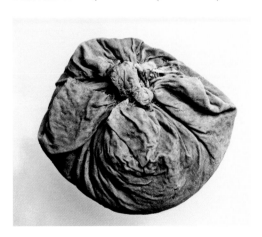

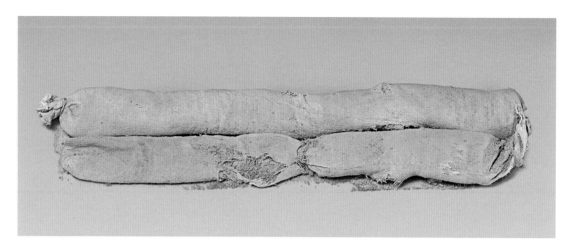

FIG. 36 Cloth cylinder filled with sawdust. Doubled, l. 39.7 cm (15⅝ in.). The Metropolitan Museum of Art, New York; Gift of Theodore M. Davis, 1909; Deaccessioned, 1957; Gift of Joseph Veach Noble, 1988

We also have preserved two sacks—which probably belonged to a more numerous lot—made like the long cylinders to hold natron and each measuring 18 x 8 x 4 centimeters (fig. 37).[30] After they had been filled and sewed up some distance above the ends, the excess cloth was ripped down vertically to make a pair of tapes 20 centimeters long and a little over 4 centimeters wide. Again it is hard to explain what the purpose of such curious bags could have been. There is no mark today to show any use, and the clean cloth of the two surviving examples makes it impossible to make any guess. However, both the long tubes and these curiously shaped bags can scarcely be considered as mere storage receptacles, and their shapes certainly should give us a hint as to their purposes.

FIG. 37 Linen sack. Formerly in the collection of The Metropolitan Museum of Art, New York (09.184.227)

FIG. 38 Five small linen sacks on a string. Formerly in the collection of The Metropolitan Museum of Art, New York (09.184.798)

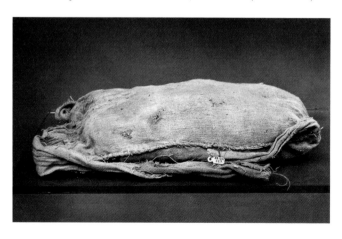

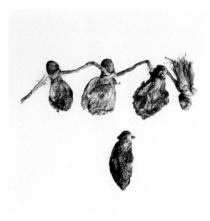

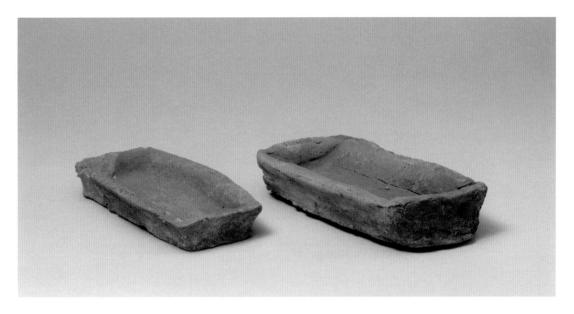

FIG. 39 Two unbaked clay dishes. Left: l. 14 cm (5½ in.); right: l. 15 cm (5⅞ in.). The Metropolitan Museum of Art, New York; Gift of Theodore M. Davis, 1909 (09.184.222, 09.184.223)

Another puzzling object from the find is a string of minute linen sacks of chaff, five in number—perhaps some sort of charm, for I can think of no other earthly use for them (fig. 38).[31] Each is made of a piece of linen folded to make a sack 1.5 centimeters square and 5 millimeters thick, and each minute sack is tied at an interval of about 2 centimeters along a central cord.

In the jars there were somewhere between forty and fifty unbaked, gray earthen dishes,* I should judge from the number of fragments that were found. Only three of the entire lot are complete, however, and they vary in size (figs. 39; 79, T).[32] The longest is 15.6 centimeters and the shortest 14 centimeters; the narrowest is 6.5 centimeters wide, and one which is practically the same length as the longest is 8 centimeters wide. They all seem to have been from 2 to 3.5 centimeters high. Each one is roughly rectangular, with fairly thick sides sloping inward toward the bottom, which is very thick and has marks from being molded on a wooden board. I have no suggestion to make as to the use of these trays other than a statement made by Daressy, who thought of them as miniature representations of fields made of Nile mud and sown with grain.[33] The mud was certainly soft when they were used for whatever ceremony they were intended. In fact, some were so badly handled as to be completely twisted out of shape, without, however, being broken. But there is absolutely no trace of the grain which Daressy suggests was put in them. Anything adhering to them seems to be just the packing material. My chief objection, however, is that Carter does not seem to have found any examples of such trays in the tomb of Tutankhamun.

The object which caused all the excitement in Theodore Davis's mind was the little plaster head* which he found right side up on top of the contents of the first jar he opened. He carried it back to his house and eventually to America, where it became part of his private collection.[34] It looks like a miniature mummy mask such as we would ordinarily expect to find on canopic bundles, but there was only the one—there were no others discovered by him— and the viscera were in the four golden coffins in the canopic jars.[35] The mask is 15 centimeters high, made up of cloth and plaster less than 1 centimeter thick all over (figs. 40a–c). The inside is unpainted, but outside it was first given a coat of yellow on which the details of the mask and jewelry were sketched in blue. Red is very sparingly used in one of the cross bands of the collar and on its ties. The eyes are black and white. The nose had been broken away before Davis took it out of the pot and, as far as I know, before the ancient Egyptians had put it in there. I can suggest no significance for the mask in the embalming ceremony.

FIGS. 40A–C Small painted mask (profile, back, and front views). Formerly believed to have come from the embalming cache, the mask dates to before Tutankhamun's time and was probably found in another tomb (perhaps KV 51) excavated by Davis. Mid-18th Dynasty. Cartonnage, h. 16 cm (6¼ in.). The Metropolitan Museum of Art, New York; Theodore M. Davis Collection, Bequest of Theodore M. Davis, 1915 (30.8.231)

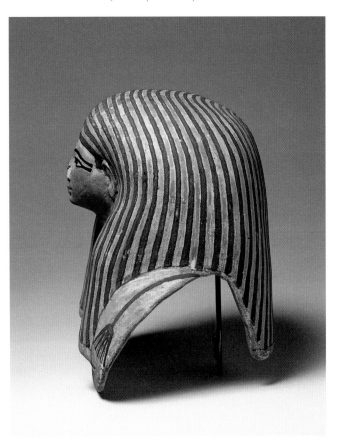
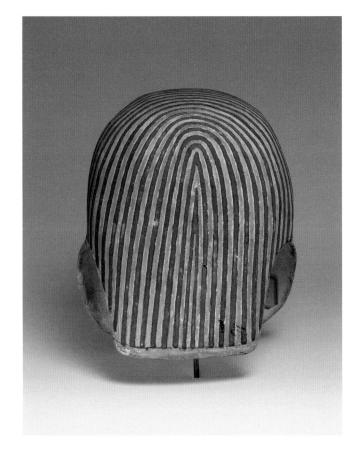

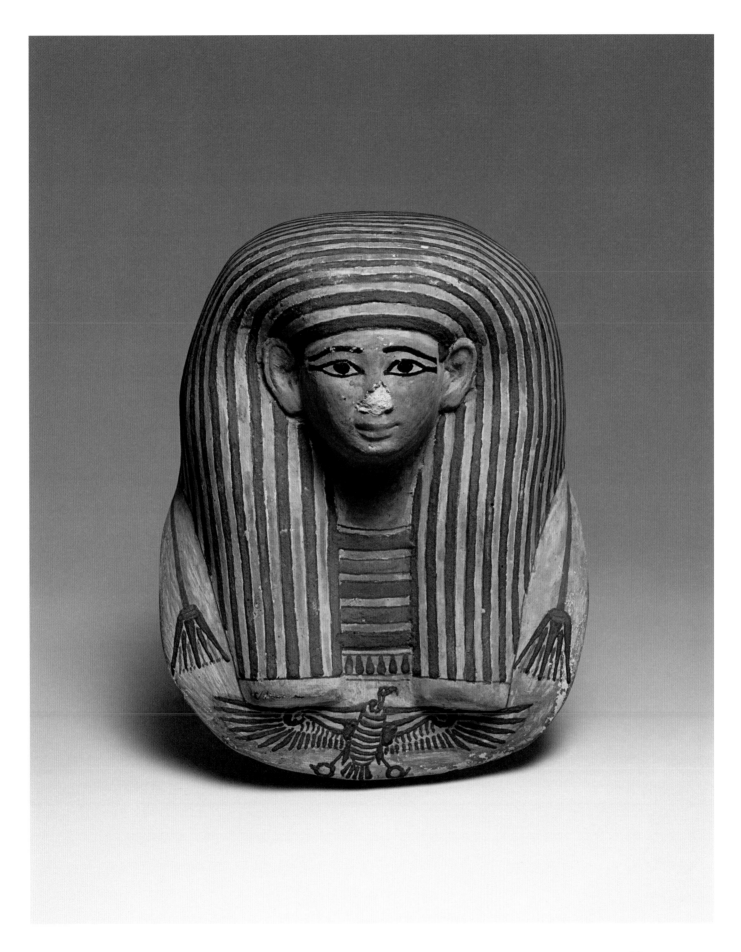

About a score of odd sticks had been tossed into the big jars (fig. 41).[36] The majority are lengths of reed, from 5 to 35 centimeters long; two are pieces of papyrus 14 centimeters long; two are wood, one with bark on it; five are wrapped with linen and two with papyrus pith; and several are charred from burning. They make a curious jumble of rubbishy fragments which defy description, but clearly many of them are probes. Some may be fragments of wickerwork objects such as were found in other tombs in the Valley of the Kings. But it must be recalled that each of these fragments had been used and thrown away as rubbish.

A certain number of objects in the pots were left in Egypt and do not form any part of Mr. Davis's gift to the Metropolitan Museum. I have found mention of a wooden tenon, a couple of pieces of limestone, and a number of square limestone blocks, fairly well polished. These last are certainly, I should say, the blocks on which the body was manipulated during the embalming,* carefully buried by those in charge of the operation. We did not find, curiously enough, anything in the nature of a bed or platform on which the body could have been laid out.[37]

The material so far described seems to have been used in the actual embalming of the body of King Tutankhamun, with here and there some magical object such as the little plaster mask whose usefulness was now over. From what I have seen of ancient Egyptian material I should say that most of these objects from the big pots are common and could have been duplicated in any period from the Old Kingdom to the Ptolemaic era. They are things which could not be thrown away because they had been in contact with the dead man's body but were too unclean from this contact to go in the tomb.

The most interesting part of the find, however, was unfamiliar to me. Most of the remaining material was obviously intended for a funeral banquet* such as we regularly see represented on the tomb walls. Sometimes, to be sure, we cannot separate the pottery used at such a banquet from the pots which have strayed in from the embalmer's shop, and therefore we have to describe all the pottery together. But certainly many of the pottery dishes and bottles, the bones of meat and fowl, and the flower collars from the jars are relics of this meal.

44

In the big jars there were some twenty-five jar lids of different sorts. Obviously they are objects thrown away when the jars which they had once covered were empty, and I think that many of them must have come from containers of embalming materials rather than from food vessels. Where the jars they once covered are now, it is quite impossible to say.

One of the lids is merely an irregular pottery chip, roughly 10 centimeters in diameter, which had been laid over the mouth of a jar and covered by a lump of plaster about 13 centimeters across and 4 centimeters thick.[38] Six other jars of the same size had as lids lengths of papyrus folded back and forth across the center to make a rough circle. In some cases they are wrapped over with strips of papyrus pith. One has a very thin coating of plaster which made the whole stopper 3 centimeters in thickness, and another has a lumpier mass of plaster which made it stand some 6 centimeters above the top of the pot. Twelve other lids of papyrus have neatly coiled, flat cores of that material, over which a strip of papyrus pith is folded back and forth and knotted in the center of the back. The smallest which we can be sure is complete is 7 centimeters in diameter, and the largest is 12.5 centimeters. All of these lids were used for bottles holding dry contents,[39] and one has a heavy, two-ply grass cord, 6.5 centimeters long, as a handle (fig. 42).

FIG. 42 Papyrus-fiber jar lids. Clockwise from the largest one in the back: diam. 10 cm (4 in.), 9.6 cm (3¾ in.), 6.3 cm (2½ in.), 8.3 cm (3¼ in.), 11 cm (4⅜ in.). The Metropolitan Museum of Art, New York; Gift of Theodore M. Davis, 1909 (09.184.250, 09.184.252, 09.184.251, 09.184.240, 09.184.241)

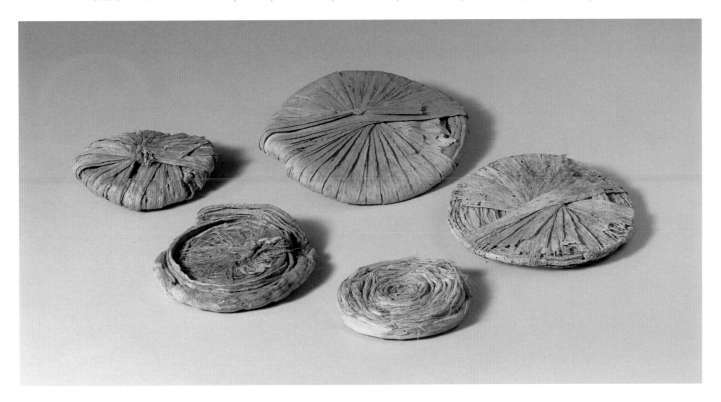

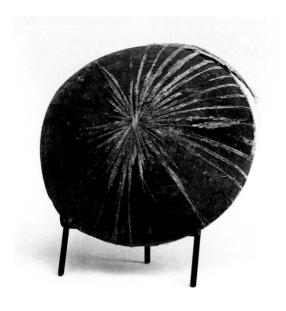

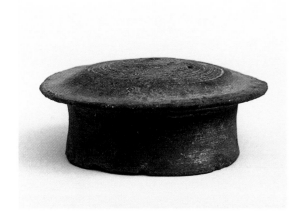

More permanent types of covers are represented by eight lids of baked clay with a red slip (fig. 79, L).[40] Three of them are very simple saucers, from 8 to 11.5 centimeters in diameter, neatly finished. In the case of at least one there is evidence that it had been held in place on top of a pot by very narrow strips of papyrus pith, which were woven back and forth to cross in the center like the wickerwork lids above (fig. 43). Two small saucers of this same type may possibly have been lids, although there is no trace of papyrus covering. The other three pottery lids are more elaborate. Their greatest diameters vary from 10 to 12 centimeters, and in each case the rims which form their lower halves were supposed to fit inside pot necks (fig. 44). The smallest in diameter is 4 centimeters high, and the other two, although much larger in diameter, are only 3 centimeters high. A curious secondary use of all three of these lids was as lamps, for the inside of the smallest is thickly encrusted with black soot, and the other two contain what looks like the dried dregs of lamp oil, in one case flecked with soot. Since these are not real lamps, they could not have been used for the illumination of a palace hall.[41] Here we should also consider three stoppers of fiber.[42] We found a bunch of grass which had been used in a jar of natron—to judge from the taste which it still preserves; a wisp of bast; and a more elaborate stopper of *halfa* grass, knotted at each end.

Also, for want of a better place to consider them, we may as well mention here two fragments of circular papyrus jar stands, which had originally been about 20 centimeters in diameter

FIG. 43 Pottery lid that was originally held in place by crossed strips of papyrus pith. Diam. 8 cm (3 1/8 in.). Oriental Institute Museum, University of Chicago (OIM 26614)

FIG. 44 Pottery lid used as a lamp. Diam. 9.9 cm (3 7/8 in.). Oriental Institute Museum, University of Chicago (OIM 26536)

FIG. 45 Conical cup. Pottery, diam. 8.7 cm (3 3/8 in.). Oriental Institute Museum, University of Chicago (OIM 26543)

FIG. 46 Conical cup. An inscription describes it as a symbolic offering of 4 "cakes (?) of *šr.t*-corn." Pottery, diam. 8.3 cm (3 ¼ in.). Oriental Institute Museum, University of Chicago (OIM 26542)

FIG. 47 Conical cup, detail of fig. 45. An inscription describes it as a symbolic offering of 31 "half-*pk* loaves"

and 3.5 centimeters thick, made of coarse fibers, each about 1 centimeter wide, and wrapped at intervals with strips of pith.[43]

Broken clay vessels made up such a large part of the contents of the storage jars that our nickname for the whole lot has always been the Davis pottery find. Very little from these vessels has been lost, even though practically everything in the big pots was broken. It must be recalled that one or two big pots were broken on the spot where they were found and the fragments of pottery in them were not brought down to Mr. Davis's house, which probably accounts for a good many missing pieces. Any other losses, we may be sure, were not intentional.

Little cups, too small to have served any practical use, should probably be considered as merely representing offerings (fig. 45). Seven, of reddish brown pottery, have labels written rapidly on them in hieratic from right to left in black ink (figs. 46–47; 76, G–M).[44] The inscriptions doubtless describe their original contents and are to be compared with marks on linen, etc., from other tombs of the same dynasty.[45] They read as follows:[46]*

G *ḥsw·t(?) ḳd·t*, 16, "? . . . ?, 16."

H *ḥry·t n šr·t*, 4, "cakes (?) of *šr·t*-corn, 4." (fig. 46)

I [*sntr n ?*]*kp*, 4, "[incense for ?] fumigation, 4."

J [*dšr·t*], (a drink).

K *ḥnk·t*, 5, "offerings, 5."

L *gśw-pkw*, 31, "half-*pk* loaves (?), 31." (fig. 47)

M *ḭrr·t*, 7, "grapes, 7."

Besides the seven inscribed offering cups already mentioned, there are sixty-five identical cups uninscribed.[47] Another little cup with a hollow foot has a crudely painted white rim inside.[48] All are very rough, and it would be fair to say that there were hundreds of them in many of the tombs in Egypt. Intrinsically there is nothing about them by which they can be dated. Possibly it would be well to call them "token offering pots."

The bottles, cups, and dishes used at the meal suggest that there were eight persons who sat around the table together.* When the meal was over the servants broke practically all the pottery*—perhaps because broken pottery can be stowed more closely than whole pots—and put it inside the big jars with the chopped straw as a packing. Most of the following vessels are tableware used on such an occasion:

A A wine jar is the only example of its kind among the Davis pottery (figs. 48, 78).[49] Its flat bottom gives it a fair stance, and its two handles—one of which still shows papyrus wrapping—make it easy to pour from. It is made of the fine, hard clay used for water jars—*qullas*—without any wash, but highly polished. The lip is a slightly sloping flange, the bottom of which would be an excellent catch for a string tying on a stopper. Sparkling or old wine probably being unknown, the Egyptian had no need of sealing his wine as tightly as we do.

B Four wine bottles,* all practically complete, were also found (figs. 49, 78).[50] Three are plain red, and the fourth is decorated. Each has a very long, thin neck and an oval body. In two cases there is a ridge on the outside of the neck; in the other two the neck is a continuous funnel. The material of all four bottles is a very good, smooth, light brown clay. The three undecorated ones have a highly polished hematite slip all over the outside, up to and including the mouth. On these the finishing line of the slip inside the mouth is very crude. On the fourth bottle, however, bands of floral decoration were painted on the shoulder and neck in black, blue, and red, and then the slip was applied to the rest of the surface and into the mouth, which has a narrow shoulder where the slip stops. The background of the bands of ornament remains the light brown of the natural clay.

C The next set also consists of four bottles, with wide, straight-walled necks (fig. 78).[51] They are made of light brown or red clay, with a dark red hematite slip on the exterior only.

D There are eight cups which were doubtless used for drinking (figs. 51, right; 78).[52] They are made of a light brown clay, covered on the outside with a dark red, highly polished hematite slip, which stops at the lip. The bottoms are slightly rounded, and the mouths flare open. On the inner surface some show deep corrugations from the wheel.

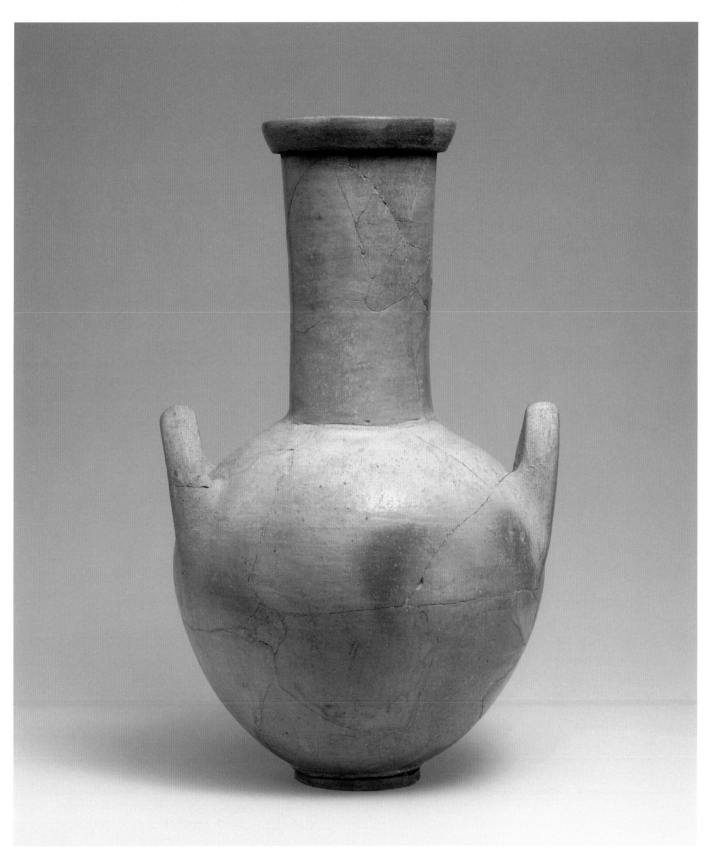

FIG. 48 Two-handled jar with polished yellow slip. This and the majority of the following vessels
have been restored from shards found inside the large jars in KV 54. Pottery, h. 33.6 cm (13¼ in.).
The Metropolitan Museum of Art, New York; Gift of Theodore M. Davis, 1909 (09.184.79)

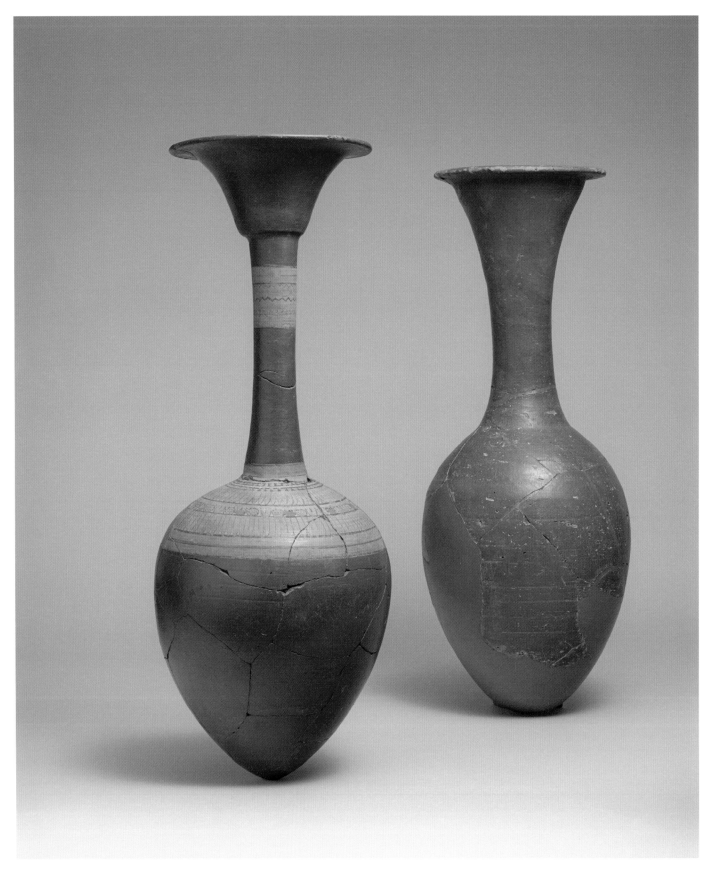

FIG. 49 Two pottery water bottles. Left: h. 37 cm (14 5/8 in.); right: h. 36.2 cm (14 1/4 in.).
The Metropolitan Museum of Art, New York; Gift of Theodore M. Davis (09.184.83, 09.184.82)

E There are also eight jars or drinking vessels, all alike in form and all but two bearing decoration.[53] They are made of light brown or red clay, with a deep red hematite slip wholly or partly covering the outer surfaces. In two cases the jars are coated with slip from top to bottom, but in the other six a strip around the shoulder has been left the natural color of the clay and decorated in blue with a pattern of garlands (figs. 53, 78). There is no question, however, that all were intended to be used in the same way. My suggestion is that they were made to hold water; they might, in fact, be called *qullas*. Having no slip of any sort on the inside, they appear to have sweated freely, the water leaving a thin film of mud in each.

F Assuming that most of the jars should appear in sets of four, I am inclined to class the following pieces together. Three are unquestionably alike, and any differences in the fourth, slenderer one probably appeared to the Egyptian inessential. The first three jars are all of one type—tall, almost shoulderless jars, of which two are now practically complete (figs. 17, left; 78).[54] The third and largest jar, of which the neck is missing, measures 33 centimeters at the point of its greatest diameter, and it seems to have been proportionately tall. The fourth jar

FIG. 50 Three hybrid alabaster versions of the water bottles in fig. 49, surrounded by symbols of Upper and Lower Egypt, from the tomb of Tutankhamun. Photograph by Harry Burton (MMA neg. no. TAA 766)

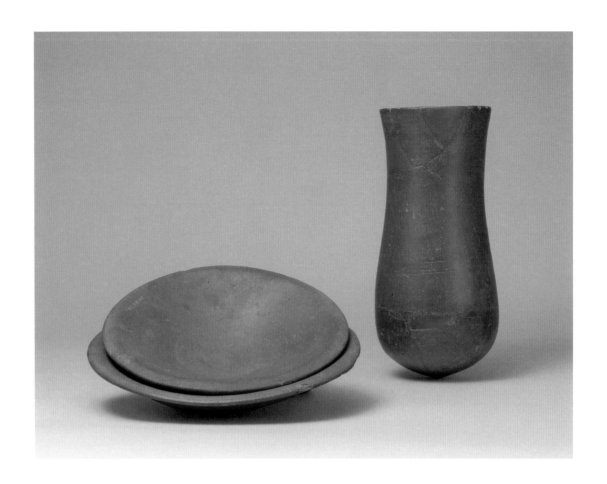

FIG. 51 Two red-polished pottery dishes
and a cup. Dishes: diam. 20.5 cm (8⅛ in.),
18.4 cm (7¼ in.); cup, h. 21.6 cm (8½ in.).
The Metropolitan Museum of Art, New York;
Gift of Theodore M. Davis, 1909 (09.184.22,
09.184.26, 09.184.88)

FIG. 52 A hybrid alabaster version of the
beaker, from the tomb of Tutankhamun.
Photograph by Harry Burton (MMA neg.
no. TAA 1068)

NEXT PAGE

FIG. 53 Two medium-sized pottery jars
and a larger one. Left to right: h. 25.6 cm
(10⅛ in.), 25.3 cm (10 in.), 32 cm (12⅝ in.).
The Metropolitan Museum of Art, New York;
Gift of Theodore M. Davis, 1909 (09.184.97,
09.184.99, 09.184.91)

is a great deal more slender than the other three, but so far as it still exists it is of the same general shape.[55] Furthermore, while the first three jars are made of a fairly clean, thin, hard, light brown clay, the walls of the fourth are thick and black on the inside. Such differences, however, were not very noticeable originally, since all four jars were whitewashed. None of the four had any surface wash which would make it impervious to liquids.

G Of identical shape with E, but much larger, are two other undecorated jars (figs. 53, right; 78).[56] The smaller of the two is made of light brown clay and has a dark red slip crudely painted on the outside only. The only remarkable point about it is that a good deal of the outer surface is black with soot from burning. The larger jar is apparently of the same shape but has no slip. Its height is unknown, since most of the neck is missing; the diameter of the body is 18 centimeters. If its neck was proportionately as high, in comparison with the smaller jar, it would probably have held half again as much as the latter.

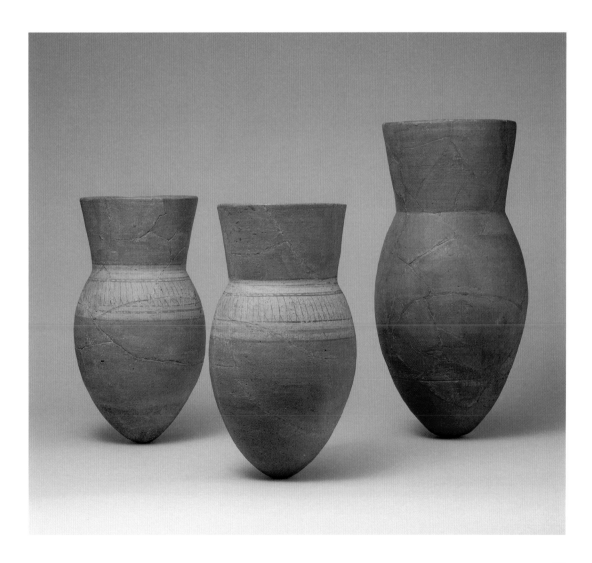

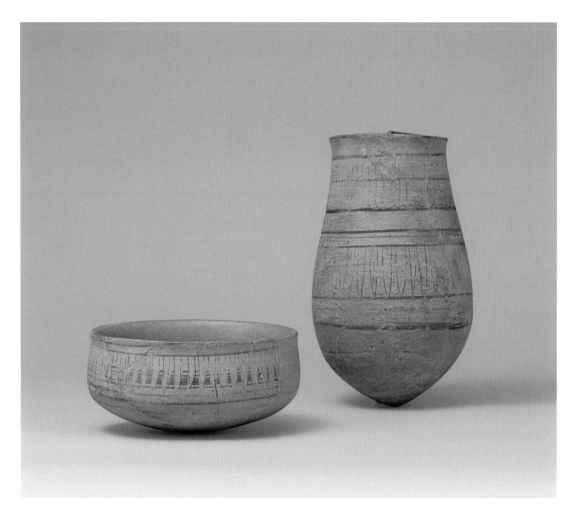

FIG. 54 A painted pottery bowl and a painted pottery cup. Bowl: diam. 13.8 cm (5³/₈ in.);
cup: h. 18.2 cm (7¹/₈ in.). The Metropolitan Museum of Art, New York; Gift of Theodore M. Davis,
1909 (09.184.105, 09.184.90)

H, J, K There are three small jars of various shapes (fig. 78). One certainly has, and the other
two possibly have, traces of mud inside, showing that they had been used to hold water. The first
is made of light brown clay without any slip.[57] The second is of light brown clay and has an ocher-
colored slip even lighter than its body material.[58] It is decorated with two broad bands of leaves
rapidly painted on the outside in blue (fig. 54, right). The third is a little bottle of brown or red
clay with a thick, red, polished hematite slip over all.[59] For such pots it is hard to state any use.

S There are a few chips from a painted bowl, originally a little over 14 centimeters in diameter
and a little more than half as deep (figs. 54, left; 79).[60] The body material and the slip are like
those of J, and a band of garlands is painted around the outer lip in light blue and red with
dark brown outlines. In the middle of the inside of the bowl the same three colors are used
in a large rosette.

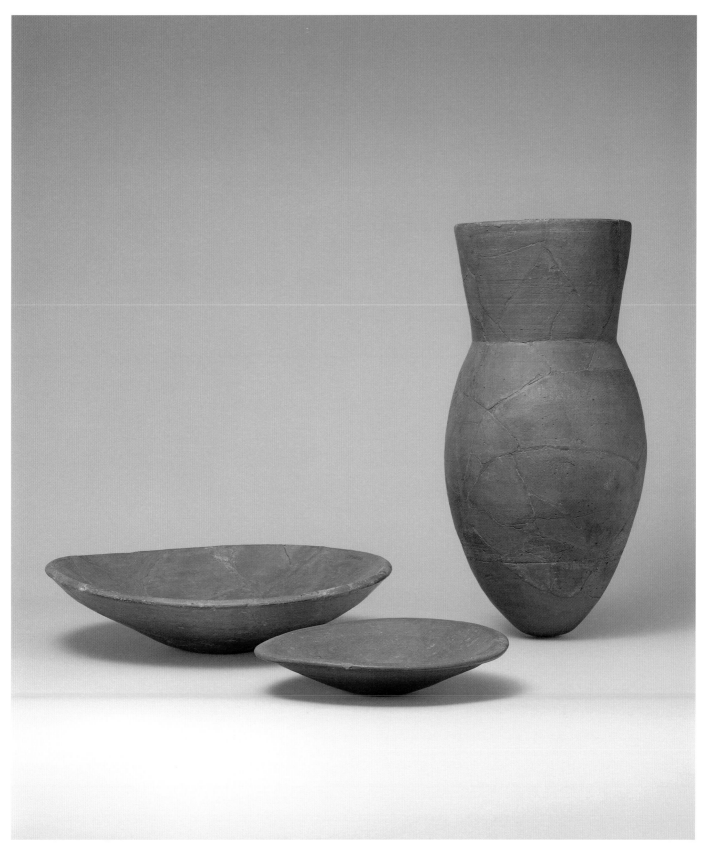

FIG. 55 Two pottery dishes and a large pottery jar. Left to right: diam. 28 cm (11 in.), diam. 18.4 cm (7 1/4 in.), h. 32 cm (12 5/8 in.). The Metropolitan Museum of Art, New York; Gift of Theodore M. Davis, 1909 (09.184.21, 09.184.26, 09.184.91)

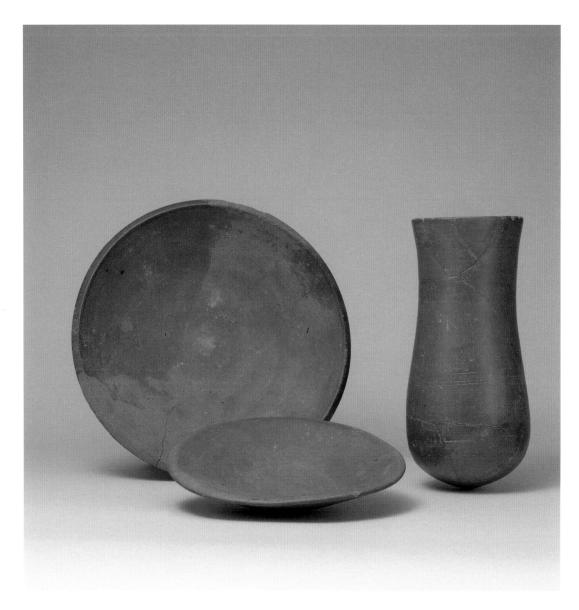

FIG. 56 Large pottery dish (partly discolored by food), dish, and beaker. Left to right: diam. 24 cm (9½ in.), diam. 18.4 cm (7¼ in.), h. 21.6 cm (8½ in.). The Metropolitan Museum of Art, New York; Gift of Theodore M. Davis, 1909 (09.184.23, 09.184.26, 09.184.88)

M Among the dish-shaped vessels one plate is unique (fig. 79).[61] It has a horizontal lip 2.5 centimeters wide and is made of light brown clay, entirely covered over, inside and out, with a clean, thick whitewash.

N–P There are some sixty-one dishes of varying shape, size, and color, but all conform more or less to the same general type (fig. 79).[62] They differ in their lips and bottoms. Occasionally the lip is a straight, horizontal line; sometimes it slopes down and out, though more often the reverse is true; but generally the lip is rounded. A few of the dishes are flat along the bottom,

but usually the outline forms a continuous curve. Sometimes we should call these pieces bowls or dishes and at other times plates or saucers. Most of them have a fine, dark red, polished hematite wash (figs. 55; 56, foreground), but a few have no wash of any sort (fig. 56, background), and a couple of saucers have a crude white strip painted around the lip.

When the dishes were packed away the majority were broken, but here and there among the smaller ones—from 24 centimeters in diameter and down—there is an occasional perfect one (figs. 55; 56, foreground). There is hardly any question that the breaking was done on purpose, for some of the larger bowls, too wide to be forced through the necks of the big jars, were shattered into innumerable pieces.

That we have here the remnants of a banquet is perfectly obvious from the bones which made up part of the contents of the jars* as they were found by Theodore Davis (figs. 57, 58).[63] Largest among the bones are the shoulder blade and connecting bones of a cow, which had been hacked with some sort of heavy cleaver, and four ribs of a sheep or goat. The majority of the bones, however, make up parts of the skeletons of nine ducks—now and then a head; occasionally legs and feet; and bits of wishbones, breastbones, shoulders, and wings. There are also parts of four geese—wings, legs, and feet. So few bones are from legs that it rather suggests that breasts and wings were the favorite part of any fowl. Of the nine ducks there are parts of four small teal (*Anas crecca*), two shovelers (*Spatula clypeata*), one gadwall (*Chaulelasmus streperus*), and two other ducks, not identified, a little bit larger than the shovelers. The bones of the geese include parts of a brent goose (*Branta bernicla*), a white-fronted goose (*Anser albifrons*), and two large bean geese (*Anser fabalis*). It is to be noted that these species do not include the domestic goose of today.

FIG. 57 Skull of a bird. Formerly in the collection of The Metropolitan Museum of Art, New York (09.184.792)

FIG. 58 Feet of a bird. Formerly in the collection of The Metropolitan Museum of Art, New York (09.184.793)

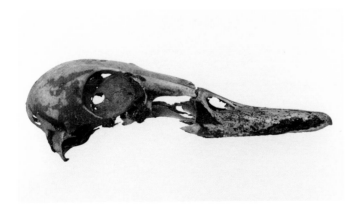

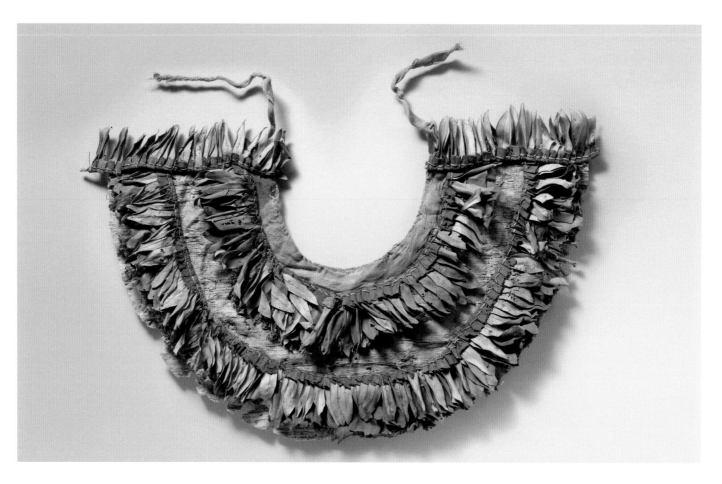

FIG. 59 Floral collar. Diam. 44 cm (17³⁄₈ in.). (For a description of the materials, see "Updating Winlock," p. 75.) The Metropolitan Museum of Art, New York; Gift of Theodore M. Davis, 1909 (09.184.215)

We can assume that all the meat was cooked, though it is impossible to be certain of this from the bones left by the banqueters. The Eighteenth Dynasty Egyptian did not use any sort of knife or fork but simply picked the food up in his hands to chew it; consequently, among the commonest things in our museums today are the pitchers and basins so necessary for washing after every meal.[64]

Originally the jars contained perhaps more than half a dozen flower collars that had been worn by those present at the banquet.* Some were torn by Mr. Davis to show how strong they still were, and the total number is therefore uncertain. Three have survived almost intact to the present day (figs. 59–66), but the others are torn into too many fragments to permit a real count.[65] Their shapes vary considerably. Two are exact semicircles, 40 and 44 centimeters in diameter and 17 and 15.5 centimeters wide. The third, 47 centimeters in diameter and 17 centimeters wide, is practically a circle, nearly but not quite closed at the back. Each collar is ingeniously

58

made of sheets of papyrus sewed together to make a backing and sometimes bound with red cloth around the edges. They are completely covered over on the front with concentric rows of olive leaves (*Olea europea*), cornflowers (*Centaurea*), and berries of the woody nightshade (*Solanum dulcamara*), these last strung in groups of four or five rows, beadlike, on thin strips of the leaves of the date palm. Now and then there are strands of very thin, bright blue faience disk beads, about 5 millimeters in diameter, run in among the berries for lengths of from 1 to 2 centimeters.

The bright colors of the flowers and berries, with here and there an edging of red cloth, surely made these now faded and dried collars very gay bits of decoration for a few hours. When they had served their purpose, some of them were folded and others merely crumpled up and stuffed into the big jars. None of them, however, was quite as elaborate as the collar found by Carter on the innermost coffin in the tomb of Tutankhamun (p. 8; fig. 67),[66] and we therefore assume that no one at this banquet had the rank of king.

FIG. 60 Floral collar, detail of fig. 59

FIG. 61 Floral collar, detail of fig. 59

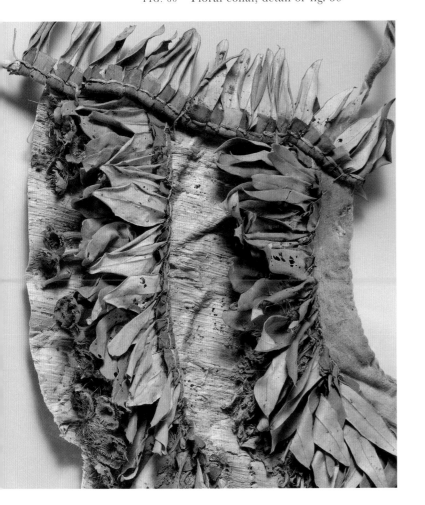

FIG. 62 Floral collar, detail of fig. 64

FIG. 63 Floral collar, detail of fig. 64

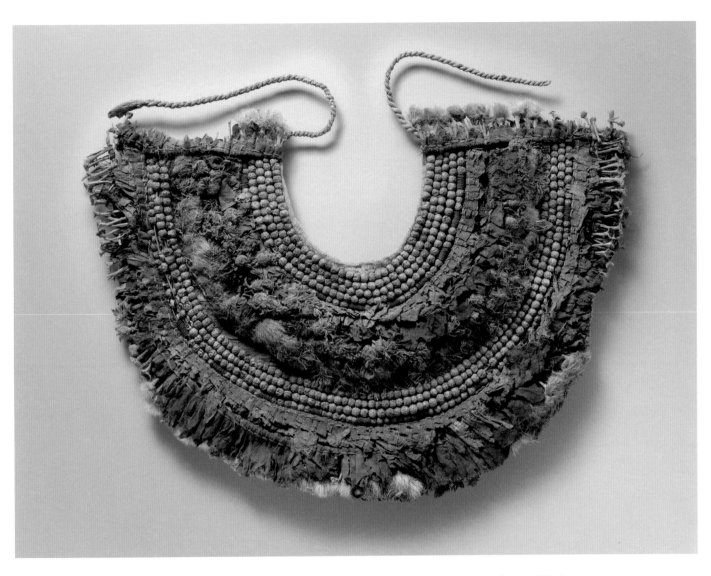

FIG. 64 Floral collar. Diam. 40 cm (15¾ in.). (For a description of the materials, see "Updating Winlock," p. 74.) The Metropolitan Museum of Art, New York; Gift of Theodore M. Davis, 1909 (09.184.214)

Two brooms, provided to sweep up sand or dust and to remove the last footprints of guests, were found in the jars.[67] They are really nothing but fagots wrapped with a piece of cord around the middle. The heavier of the pair is made of some fifteen or twenty pieces of reed, each one about 5 millimeters in diameter and all so worn down that the longest is about 25 centimeters, and the shortest 15 centimeters, long. The binding material in this case is a piece of cloth. The smaller broom consists of some eight stumps of grass pulled out of the ground, each one about 12 centimeters long and about 2 millimeters in diameter at the base. They are bound with a piece of fine string. Both brooms had seen hard use, perhaps sweeping away the footprints of those who had attended the funeral ceremonies of King Tutankhamun.[68]

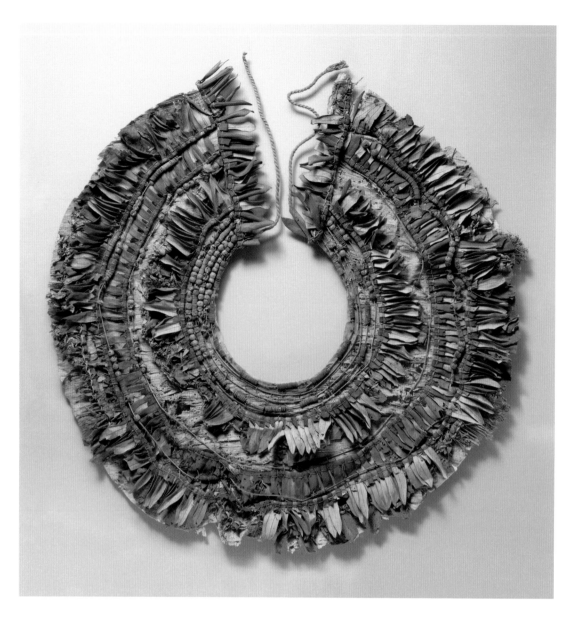

FIG. 65 Floral collar. Diam. 47 cm (18 ½ in.). (For a description of the flowers, see "Updating Winlock," p. 75.) The Metropolitan Museum of Art, New York; Gift of Theodore M. Davis, 1909 (09.184.216)

Embalmers' caches are known in the Theban necropolis at least as early as the Eleventh Dynasty and as late as the end of the pagan period. Other than the fact that here we have bits of bandages and bags of natron and salt—and, of course, the charming little mask—there is nothing about this lot of material to recommend it to us particularly, except that, naturally, anything with the name of Tutankhamun upon it will always have an interest for us. But remnants of a last funerary banquet have, so far as I know, not been found heretofore. It would be extremely interesting to know the names and quality of the persons who partook of this meal, but even

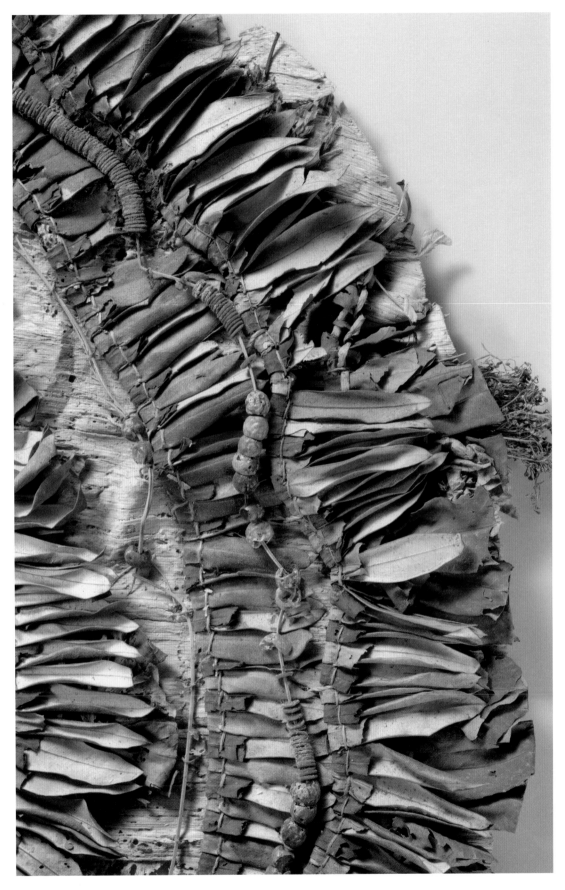

FIG. 66 Floral collar, detail of fig. 65

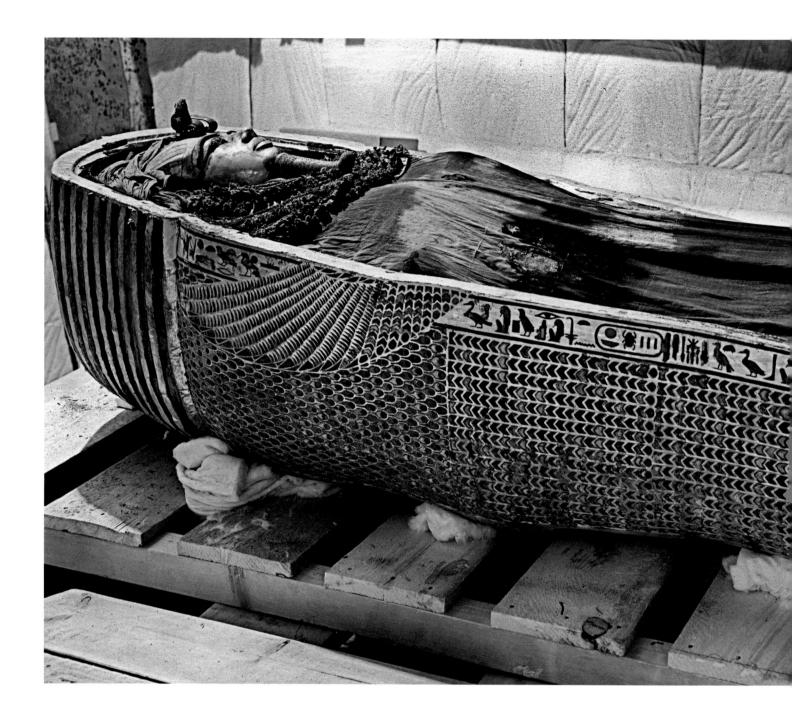

in Egypt it would be asking a good deal to discover such details. It is enough to know that it was

a meal which consisted of meat and fowl, and probably bread and cakes, and that it was washed

down with copious draughts of wine or beer and water. At the end, as the eight people who

partook of it withdrew from the room, their footprints were swept away and the door was closed.

Whether or not this gathering up of the remains of such a meal is to be considered an innovation

of the period of the heresy, I know of no other trace of it. But then we must always remember

that this is probably the only known cache of its kind belonging to a king.[69]

FIG. 67 Tutankhamun's second coffin, with the lid removed to show the innermost solid gold coffin covered from neck to foot with a three-times folded, resin-stained linen shroud; a floral collar lies across the chest. Photograph by Harry Burton (MMA neg. no. TAA 1349)

1 R. Englebach, in *Annales du Service des Antiquités*, XL (1940), p. 147, says he ascended the throne in 1369 B.C. and died in 1360 B.C.

2 MMA acc. nos. 09.184.1–170, 214–697, 788–805. In subsequent references the serial numbers 09.184 will be omitted.

3 Such slings were used everywhere in Egypt, and examples found by the Museum have been mentioned in the *Bulletin of The Metropolitan Museum of Art*, XV (1920), July, part II, p. 12, XVII (1922), Dec., part II, p. 34, fig. 34, and XXXII (1937), Jan., sect. II, fig. 39; and Winlock, *The Tomb of Queen Meryet-Amūn at Thebes* (New York, 1932), p. 32, fig. 18, pl. XXXI.

4 Nos. .1–.7, including the neck of a seventh pot.

5 No. .329. The identification was made by Dr. M. L. Britton in December 1916, when he was Director of the New York Botanical Garden. Other identifications of his will be found below in the description of the flower collars.

6 Theodore M. Davis, *The Tomb of Queen Tîyi* (London, 1910), p. 4, and *The Tombs of Harmhabi and Touatânkhamanou* (London, 1912), pp. 3, 112, 135, fig. 15. The last reference (p. 135) is in an article by G. Daressy. Eventually I gave Howard Carter further information about the find, and he used it in *The Tomb of Tut·ankh·Amen* (London, 1923–1933), I, p. 77, and II, p. 97.

7 Nos. .260–.265.

8 Cf. H. R. Hall, *Catalogue of Egyptian Scarabs, Etc., in the British Museum*, I (London, 1913), no. 1873. Another reconstruction might be ⟨hieroglyphs⟩; *ibid.*, no. 1823 in Percy E. Newberry, *Scarabs* (London, 1908), pl. XXXI, 10. Both are of Amenhotep III. See also the Catalogue of the Sale of the Collection of James Burton (Sotheby & Co., London, July 25, 1836), no. 268. This is a seal taken from a door in the tomb of Amenhotep III, which according to the priced catalogue in the Edwards Library was not bought by the British Museum.

9 Among the many examples see Newberry, *Scarabs*, p. 89; Carter and Newberry, *The Tomb of Thoutmôsis IV* (*T. M. Davis' Excavations: Biban el Molûk*) (Westminster, 1904), p. XXX; Davis, *The Tomb of Queen Tîyi*, p. 8.

10 Nos. .235 A–E.

11 No. .220.

12 For Maspero's article see *Recueil de travaux*, XXXII (1910), p. 88; the reference to the tomb of Tiye is a misunderstanding. For Davis's and Daressy's see above, note 6. For Lythgoe's see MMA *Bulletin*, XVIII (1923), p. 100. Mention of the cloth after Maspero was made by A. J. Reinach, *Revue archéologique*, II (1911), p. 332, and H. Gauthier, *Le Livre de rois d'Égypte* (Cairo, 1912), II, p. 365. The linen sign is as in my copy. Carter seems to say (*Tut·ankh·Amen*, I, p. 78) that this inscription was on a head cloth.

13 No. .693.

14 Carter, *Tut·ankh·Amen*, II, pp. 107 and 185. The latter is in Lucas's report.

15 Nos. .655–.660.

16 Nos. .407 ff.

17 Nos. .424–.560 and .662–.666 (*passim*).

18 No. .664.

19 No. .663.

20 Nos. .694–.697.

21 Nos. .569, .577, .643 A, B.

22 Nos. .667–.692.

23 Nos. .364, .407 ff (*passim*), and .797.

24 No. .661.

25 No. .653.

26 Nos. .217–.219; Winlock, MMA. *Bulletin*, XI (1916), p. 238; H. Schäfer, *Zeitschrift für ägyptische Sprache und Altertumskunde*, 68 (1932), p. 81; Winlock, *The Private Life of the Ancient Egyptians* (New York, 1935), fig. 9.

27 Nos. .228–.231, .266 ff (*passim*).

28 Nos. .232–.234, .267 ff (*passim*).

29 Nos. .224, .225, .313–.315.

30 Nos. .226, .227.

31 No. .798.

32 Nos. .221–.223.

33 Daressy in *The Tombs of Harmhabi and Touatânkhamanou*, p. 106.

34 Now in his collection in the Metropolitan Museum, acc. no. 30.8.231.

35 Carter, *Tut·ankh·Amen*, III, p. 35, pl. LIV.

36 No. .358.

37 Equipment from embalmers' shops is known. An embalmer's platform of the XI Dynasty is mentioned by me in the MMA *Bulletin*, XVII (1922), Dec., part II, p. 34; and a wicker bed and mat of the Late Period in the MMA *Bulletin*, XIX (1924), Dec., part II, p. 32. A limestone table in the shape of a bed of the Late Period is described by me in *Annales du Service des Antiquités*, XXX (1930), p. 102. Several such caches were found by Lansing in the Asasif; see MMA *Bulletin*, XV (1920), July, part II, p. 12.

38 No. .239.

39 Nos. .240–.257.

40 Nos. .74, .75, .102–.104, .236–.238.

41 N. de G. Davies, *The Rock Tombs of el Amarna*, III (London, 1905), pl. VII, shows the tall lamps used in the dining room.

42 Nos. .316, .317, .321.

43 Nos. .319, .320.

44 Nos. .107–.113.

45 For instance, Winlock, *The Tomb of Queen Meryet-Amūn at Thebes*, pp. 33 and 75, pl. XV.

46 The transcriptions here given were made before the war of 1914 by Alan H. Gardiner and checked by Ludlow Bull in 1941.

47 Nos. .114–.170, .798–.805. H. 3.5–7 cm, diam. 6.5–10 cm.

48 No. .106. H. 7 cm, diam. 10.5 cm.

49 No. .79. H. 33.5 cm, diam. of body 20 cm, diam. of mouth 10 cm. Capacity 3500 cc.

50 Nos. .80–83. H. 36–37 cm, diam. of body 15–15.5 cm, diam. of mouth about 12 cm. Capacity 1200–2000 cc.

51 Nos. .76–.78, .98. H. 27.5–28 cm, diam. of body 16–16.5 cm, diam. of mouth 10–11 cm. Capacity about 2250 cc.

52 Nos. .85–.88 and four unaccessioned (broken). H. 21–23 cm, diam. of body 10.5–11 cm, diam. of mouth 9–10 cm. Capacity 730–1045 cc.

53 Nos. .93–.97, .99–.101. H. 24.5–26 cm, diam. of body 13.5–14.5 cm, diam. of mouth 12–13 cm. Capacity 1850–2060 cc.

54 Nos. .8, .9, .11. H. of complete jars (nos. .8 and .9) 58 and 55.5 cm, diam. of body 30 and 29 cm, diam. of mouth 23.5 and 21 cm, capacity 18,300 and 14,650 cc., respectively.

55 No. .10. H. (existing) 60 cm, diam. of body 21 cm.

56 Nos. .91, .92. H. of no. .91, the smaller, 33 cm, diam. of body 17 cm, diam. of mouth 14.5 cm. Capacity 3800 cc.

57 No. .89. H. 17 cm, diam. of body 12.2 cm, diam. of mouth 9.2 cm. Capacity 720 cc.

58 No. .90. H. 18.5 cm, diam. of body 11.7 cm, diam. of mouth 8 cm. Capacity 730 cc.

59 No. .84. H. 14.2 cm, diam. of body 8.6 cm, diam. of mouth 3.7 cm. Capacity 200 cc.

60 No. .105.

61 No. .24. Diam. 22.5 cm, depth 5 cm.

62 Nos. .12–23, .25–73. Diam. 9–46 cm, depth 2.5–14 cm.

63 Nos. .330–.406, .788–.796. Identification of the bones has recently been made for me by Dr. James P. Chapin of the American Museum of Natural History. Among them he identified the "proximal extremity of a human ulna of the left arm." This undoubtedly is a stray which got among these bones in Mr. Davis's storeroom.

64 A charming sketch of this period is in E. Denison Ross, *The Art of Egypt through the Ages* (London, 1931), p. 163. A pitcher and basin are shown in Winlock, *The Private Life of the Ancient Egyptians*, fig. 14.

65 Nos. .214–.216, .323–.328 (fragmentary). See Carter, *Tut·ankh·Amen*, I, p. 78, and II, p. 98. No. .214 is fig. 49 in the MMA *Handbook of the Egyptian Rooms* (New York, 1911 and 1916). Like the wheat chaff described in footnote 5 above, the floral components of the collars were identified by Dr. Britton.

66 Carter, *Tut·ankh·Amen*, II, pp. 78 and 191 (in Appendix III by P. E. Newberry), and pl. XXXVI.

67 Nos. .318, .322.

68 For similar brooms and this ceremony see the MMA *Bulletin*, XVII (1922), Dec., part II, p. 36, and XXIII (1928), Dec., part II, p. 24.

69 This account of the Theodore M. Davis pottery find would never have been made by me without the help of Charlotte R. Clark. All the drawings are by Lindsley F. Hall.

Updating Winlock

AN APPENDIX OF RECENT SCHOLARSHIP

Dorothea Arnold, with Emilia Cortes

The following notes correspond to sections in Winlock's text that are marked with an asterisk, explaining where new research has led to important additions or revisions. Entries that are initialed "EC" cite new textile analyses (at a magnification of 10x to 200x) conducted in 1999 and 2010 by Emilia Cortes, Associate Conservator, Department of Textile Conservation, The Metropolitan Museum of Art.

For a listing of the vast literature on Tutankhamun, see Geoffrey T. Martin, *A Bibliography of the Amarna Period and Its Aftermath: The Reigns of Akhenaten, Smenkhkare, Tutankhamun, and Ay* (London and New York, 1991), or consult the Aigyptos database, www.aigyptos.uni-muenchen.de/indexe.htm, maintained by the Institute of Egyptology, University of Munich, in cooperation with the Department of Egyptology, University of Heidelberg.

p. 21 **the funeral of King Tutankhamun in 1360 B.C.** Winlock used a now outdated chronology of ancient Egypt. For the dates presently used by The Metropolitan Museum of Art, see Dorothea Arnold, *The Royal Women of Amarna: Images of Beauty from Ancient Egypt*, exh. cat. (New York, 1996), p. XIX.

p. 21 **Sometime early in January 1908** The pit was actually first opened on December 21, 1907. See Nicholas Reeves, *Valley of the Kings: The Decline of a Royal Necropolis* (London and New York, 1990), p. 69.

p. 21 **the tomb of Ramesses XI (no. 18).** KV 18 is now believed to be the tomb of Ramesses X.

p. 21 **a charming little yellow mask** Nicholas Reeves argues convincingly that the mask in The Metropolitan Museum of Art (MMA 30.8.231; fig. 40) and documented in Winlock's 1941

publication is not, in fact, the one found in Tutankhamun's embalming cache but a piece Davis discovered in 1906, in an unidentified tomb (KV 51); it probably covered a wrapped packet of viscera. The small mask actually found in the cache was most likely a gilded piece now in Cairo's Egyptian Museum (JE 39711; fig. 68), which was made to cover the head of the mummy of one of the stillborn fetuses in Tutankhamun's tomb but somehow became separated and ended up in the embalming cache. When Davis made his final bequest to the Metropolitan

FIG. 68 Small gilded cartonnage mask, possibly prepared for the mummy of the older stillborn fetus found in Tutankhamun's tomb. Egyptian Museum, Cairo (JE 39711)

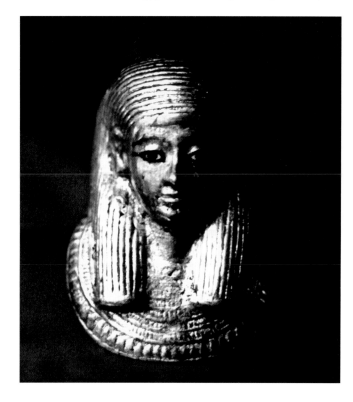

Museum, he made up for the loss of that piece with the gift of the small mask from KV 51. See Nicholas Reeves, "On the Miniature Mask from the Tut'ankhamūn Embalming Cache," *Bulletin de la Société d'Égyptologie Genève* 8 (1983), pp. 81–83; and Reeves, *The Complete Tutankhamun: The King, the Tomb, the Royal Treasure* (London, 1990), pp. 38, 123.

p. 23 **and entered in the catalogue.** Of the pieces referred to in Winlock's second footnote, only the following remain in the Museum's collection (all serial numbers begin 09.184): .1a–b, .8, .21–.23, .26, .79, .82–.83, .88, .90–.91, .97, .99, .105, .214–.220, .222–.223, .235a–e, .240–.244, .250–.252, .255, .257, .260–.265, .358a–b, .693, .797.

The other items were deaccessioned. The pots are now in the collection of the Oriental Institute Museum at the University of Chicago; some bandages are in the American Museum of Natural History, New York; and other textiles are in the Textile Museum, Washington, D.C. Not all the institutions holding these deaccessioned objects are known, and, unfortunately, not all objects were photographed before they were deaccessioned. The black-and-white photographs published here are from the record cards of the Department of Egyptian Art, The Metropolitan Museum of Art, created when the objects were still in the collection.

Susan Allen has summarized the complete group of objects in the find according to Winlock's text and the record cards in The Metropolitan Museum of Art's files: 185 pottery vessels; 19 lids of papyrus; 3 fiber jar stoppers; bones of ducks, geese, cow, and sheep or goat; 3 floral collars (plus many fragments); 2 fiber brooms; 3 linen head covers; 3 linen sheets with inscriptions; 180 linen bandages; 24 lengths of cloth ripped from sheets; 4 pink-dyed linen pieces ripped for bandages; 26 wide linen pieces (including one torn from a shirt); 50 pieces of specially woven linen tape or bandage; 61 bundles or packets of natron and chaff; about 20 sticks of reed, papyrus, and wood, some burnt; 4 small blocks of limestone, fairly well polished. Allen does not mention the seals and small gold mask. See Susan Allen, "Tutankhamun's Embalming Cache Reconsidered," in *Egyptology at the Dawn of the Twenty-First Century: Proceedings of the Eighth International Congress of Egyptologists, Cairo, 2000*, edited by Zahi Hawass and Lyla Pinch Brock, 3 vols. (Cairo, 2003), vol. 1, p. 26.

p. 24 **today called no. 54** As mentioned in the Introduction, Nicholas Reeves has proposed that the large jars with embalming material were originally deposited along the wall of the entrance corridor into Tutankhamun's tomb, where similar materials were also found, and Susan Allen has reconstructed how the pots would have looked in that location. However, the recent discovery of KV 63 suggests this interpretation must be reconsidered. See Introduction, p. 16. See also Reeves, *Valley of the Kings: The Decline of a Royal Necropolis*, pp. 67–69; Allen, "Tutankhamun's Embalming Cache Reconsidered," pp. 23–29.

p. 26 **objects from the funerary banquet of King Tutankhamun** As explained in the introduction, the interpretation of these objects has since changed. See also pp. 72–73, note to p. 44.

p. 28 **earlier and later masses of such materials** For Winlock's finds of other such caches see his *Excavations at Deir el-Bahri, 1911–1931* (New York, 1942), pp. 55–57, 165–67, pls. 18, 94.

p. 28 **mud impressions of ring or scarab seals** See Olaf E. Kaper, "The Door Sealings and Object Sealings" in *Stone Vessels, Pottery and Sealings from the Tomb of Tut'ankhamun*, edited by Ali el-Khouli, Rostislav Holthoer, Colin A. Hope, and Olaf E. Kaper (Oxford, 1993), pp. 156, 165–77.

p. 28 **The sixth is illegible.** It is actually just a blob of mud around a piece of papyrus string.

p. 30 **in cursive hieroglyphs and reading** No updating of Winlock's readings of the linen marks has been attempted here.

p. 30 **Its length, 94 centimeters, is the original length of the sheet, but its original width is indeterminable, since it is now ripped down to 32 centimeters. The cloth is of medium texture, with seventeen warp threads and twenty-two woof threads to the centimeter.** MMA 09.184.220 (fig. 24; 77, A) is 100 cm long, including a 3.5-cm warp fringe; the existence of weft headings, weft finishes, and a few warp knotted fringes show that this is indeed the loom length, the original length of the sheet. The width is now 33.5 cm, including a weft fringe of 1.5 cm. The warp count varies from 18 to 26 per cm and the

weft count from 18 to 22 per cm, single yarns, S-twist. The weave is dense near the selvage. (EC)

p. 30 **A fringe of 1.5 centimeters wide is woven into the top.** Winlock was looking at the object from a different direction from the weaver and so placed the fringe at the top. When the object was woven on the loom, the supplementary 1.5-cm-long weft fringe was woven in the weft direction on the left side of the loom at the same time as the textile. The fringe is made of single yarns, S-twist, grouped as three to five yarns in a single weft. (EC)

p. 30 **One end has a selvage** Again, Winlock was looking at the object from a different direction from the weaver, so he is actually describing the headings. The only existing selvage, 0.5 cm wide, is woven together with the weft fringe, and it is made of sixteen warps woven in eight groups of two warps, each warp single yarns, S-twist. (EC)

p. 30 **and the other a selvage partly raveled out, as though for fringing.** In this case, because of Winlock's direction, he is describing the weaving end finishes. There is only one selvage on this textile; on the opposite side, the object is torn, which is why it is not possible to know the original width of the textile. The object's weaving structure is 1/1 balanced plain weave. (EC)

p. 32 **Of even greater importance is a large piece of sheet 2.44 meters long and 61 centimeters wide (figs. 25; 77, B). Its length is the original length of the sheet, for one end is rolled and hemmed and the other shows traces of a selvage.** MMA 09.184.693 (fig. 25; 77, B) is 2.51 m long and 62 cm wide. This is the original length of the sheet, but the object was cut before hemming, leaving no finishes. The stitching thread is made of two single yarns, S-twist plied Z. The "traces of a selvage" are, in fact, the headings of the weave. (EC)

p. 32 **The sheet is of very fine, tightly woven but not heavy linen, with thirty-six warp threads and twenty-eight woof threads to the centimeter.** The weaving structure is 1/1 warp face. The count is 80 warps and 26 to 30 wefts per cm, single yarns, S-twist. (EC)

p. 32 **The signs are in white thread, the same color as the cloth itself, but, being a somewhat tighter weave, they are quite legible** The hieroglyphs were made by weaving together two to four supplementary single yarns, S-twist in the warp and weft directions, into the foundation of the textile. (EC)

p. 32 **some 9 centimeters from the selvage end** Again, Winlock was looking at the object from a different direction, so these are the headings. (EC)

p. 33 **from the other, hemmed end** These are the finishings of the textile. (EC)

p. 36 **Their widths run from 1.8 centimeters to 11 centimeters. The lengths to which they were woven cannot be determined because in every case both ends are torn off, but the longest is 4.70 meters long and the shortest a mere scrap 39 centimeters long.** The bandage MMA 09.184.797 (fig. 30) is 164 cm long and 5.5 cm wide; there are no headings and no end finishes, so the original length cannot be determined. The warp count in the center is 36 yarns per cm and in the selvages is 72 yarns per cm, single yarns, S-twist. The weft count is 24 yarns per cm, single yarns, S-twist. The object weaving structure is 1/1 balanced plain weave in the center area and 1/1 warp face plain weave near the selvages. (EC)

p. 37 **These are kerchiefs** At least 38 similar textile pieces were found in the tomb of Tutankhamun itself, where they were folded into small bag-shaped pads and placed in boxes and a linen bundle on or near one of the large couches in the antechamber (fig. 69). The measurements Carter gives in his notes are about 56, 60, and 65 cm for the front width, and 48, 51, and 51 cm for the length from the middle of the forehead to the middle of the semicircular back—a fairly good match to the measurements of the Davis pieces described by Winlock. Carter refers to them as "apron-shaped loin cloths," which might explain why Winlock does not refer to the similarity here. See the Howard Carter Archives on the Griffith Institute's website "Tutankhamun: Anatomy of an Excavation," http://www.griffith. ox.ac.uk/gri/carter (objects 46i, 46j, and 46k); Helen Murray and Mary Nuttall, *A Handlist to Howard Carter's Catalogue of Objects in Tut'ankhamun's Tomb* (Oxford, 1963), pp. 3–5, nos. 46i, 46j, 46k, 46vv, 50m, and 101aa.

Winlock might, in fact, have been the first to identify the true function of these cloth pieces. However, the exact way in which these cloths were arranged on the head is still not quite clear. Gillian Vogelsang-Eastwood first postulated that they were similar to the scarves worn by servants in statues and representations from the Old Kingdom onward (fig. 70), but by 1999 she had changed her mind and identified them as *khat* headdresses worn by members of the royal family and deities. See Vogelsang-Eastwood, *Pharaonic Egyptian Clothing* (Leiden, 1993), pp. 171–78; Vogelsang-Eastwood, *Tutankhamun's Wardrobe* (Rotterdam, 1999), pp. 64–66; Marianne Eaton-Krauss, "The *Khat* Headdress to the End of the Amarna Period," *Studien zur Altägyptischen Kultur* 5 (1977), pp. 21–39.

The topic requires further research. In a trial using reproductions in cotton, conducted by Dorothea Arnold, Emilia Cortes, and members of the Museum's Costume Institute, it became apparent that the smaller examples do not have enough material at the sides to form the characteristic pouches of the *khat*, as seen in statuary from the time. With the somewhat larger examples, pouches could be achieved by tucking the corners up into the edges fastened behind the ears, but these pouches were still much smaller than what is seen in representations of people wearing the *khat* (fig. 71). Is the artistic version simply representing the *khat* in a larger-than-life manner? Were,

FIG. 70 Limestone statuette of a nurse wearing a kerchief over her hair or wig. H. 10.5 cm (4⅛ in.), 5th Dynasty, ca. 2420–2389 B.C. The Metropolitan Museum of Art, New York; Purchase, Edward S. Harkness Gift, 1926 (26.7.1405)

FIG. 69 A head cover found inside a bundle on the king's lion couch in the tomb of Tutankhamun. Photograph by Harry Burton (MMA neg. no. TAA 814)

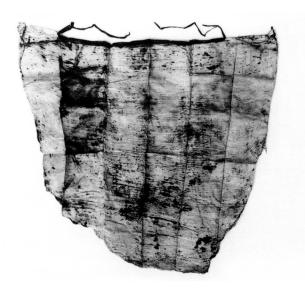

perhaps, the servant's headscarf and the *khat* in reality the same garment, depicted differently according to the status of the figure shown wearing it? Concerning the Davis head covers, it is still most likely that they were worn by the embalmers and, consequently, would have been more akin to the servants' kerchiefs. Evidence of darning and laundering can clearly be seen on the Davis head covers in the Metropolitan Museum, indicating that these pieces were cherished possessions (fig. 33c).

p. 37 **with the edges turned in and sewed over and over** At the edges, the two layers of fabric are rolled toward the reverse side and stitched. MMA 09.184.217 (fig. 33): The stitching thread is undyed, two single yarns, S-twist plied Z, and on the right side there is a series of five knots made of two single yarns, S-twist plied Z (at 5, 10, 11.5, 13, and 5 cm from the forehead edge). MMA 09.184.218 (fig. 32): The stitching thread is undyed, two single yarns, S-twist plied Z. MMA 09.184.219 (fig. 31): The stitching thread is undyed, single yarn, S-twist. (EC)

p. 37 **and had been darned anciently.** MMA 09.184.217 shows evidence of ancient darning with dyed blue thread, single yarn, S-twist, on the upper right side (fig. 33c). (EC)

p. 37 **The front of each kerchief is a straight edge and the back rounded; a tape some 92 centimeters long** The tape in MMA 09.184.218 is 90.5 cm long; in MMA 09.184.219 it is 91 cm long. Both are 1.5 cm wide. (EC)

p. 38 **The lengths from the middle of the forehead to the middle of the semicircular back are 40, 51, and 52.5 centimeters, and the widths in front are 53, 66, and 68.5 centimeters—the blue kerchief being the smallest. All three kerchiefs are made of very light and fine linen; in two cases the threads number thirty by sixty to the square centimeter, and in the third there are as many as thirty-five by seventy-five.** MMA 09.184.217 (fig. 33) is 39 cm long, 53 cm wide. The warp count is 66 to 68 per cm, single yarns, S-twist, and the warps are parallel to the forehead edge. The weft count is 48 to 50 per cm, single yarns, S-twist. The weaving structure is 1/1 balanced plain weave. MMA 09.184.218 (fig. 32) is 49.5 cm long, 63.5 cm wide. The warp count is 56 to 64 per cm, single yarns, S-twist, and the warps are parallel to the forehead edge. The weft count is 26 to 40 per cm, single yarns, S-twist. The yarn diameter is 0.5 mm, and the weaving structure is 1/1 balanced plain weave. MMA 09.184.219 (fig. 31) is 52.5 cm long, 68.5 cm wide. The warp count is 68 to 72 per cm, single yarns, S-twist, and the warps are parallel to the forehead edge. The weft count is 38 to 39 per cm, single yarns, S-twist. The yarn diameter is 0.01 mm, and the weaving structure is 1/1 balanced plain weave. (EC)

p. 38 **probably the juice of the *sunt* berry (*Acacia nilotica*).** In 1987 the presence of indigotin (indigo) was identified with chemical analysis by Nobuko Kajitani, then the head of the Museum's Department of Textile Conservation. It was confirmed in 2010 with fiber optics reflectance spectroscopy analysis by Yae Takahashi, Sherman Fairchild Fellow in the Department of Scientific Research, The Metropolitan Museum of Art.

p. 38 **bags of chaff** The chaff is now believed to have been used as stuffing in the body cavities. See Renate Germer, *Mummies: Life after Death in Ancient Egypt* (New York, 1997), pp. 23–24.

FIG. 71 Shabti of King Akhenaten wearing a *khat* headdress (front and profile views). 18th Dynasty, ca. 1336 B.C. Faience, h. 11 cm (4 ³/₈ in.). The Metropolitan Museum of Art, New York; Purchase, Fletcher Fund and The Guide Foundation Inc. Gift, 1966 (66.99.37)

 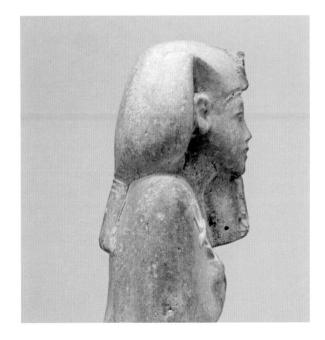

p. 39 **We also found at least five long cloth cylinders** These were possibly also used to fill the body before it was wrapped. Analysis by Mark Wypyski, Research Scientist in the Museum's Department of Scientific Research, has shown the content of the bag in fig. 36 to be decomposed plant material, most probably wood. An identification as sawdust is therefore a good possibility.

p. 41 **unbaked, gray earthen dishes** These dishes of unfired clay appear to be simplified versions of purification basins of a symbolic nature. See J. F. Borghouts, "Libation," in *Lexikon der Ägyptologie*, edited by Wolfgang Helck and Wolfhart Westendorf, 7 vols. (Wiesbaden, 1980), vol. 3, cols. 1014–15.

p. 42 **the little plaster head** See above, p. 67, note to p. 21.

p. 44 **the blocks on which the body was manipulated during the embalming** Two such limestone blocks were found in the royal tomb at Amarna. See Geoffrey T. Martin, *The Royal Tomb at El-'Amarna: The Rock Tombs of El-'Amarna, Part VII*, 2 vols., Archaeological Survey Memoirs (London, 1974), vol. 1, p. 94, pl. 55, no. 402.

p. 44 **obviously intended for a funeral banquet** As pointed out in the Introduction, the scenes in nonroyal Theban tombs of the Eighteenth Dynasty to which Winlock refers here do not, in fact, depict funeral banquets. A decade after Winlock published his text, Siegfried Schott presented persuasive evidence that these paintings illustrate an annual festival—the "Beautiful Feast of the Valley"—which was celebrated by the people of Thebes in and around the tombs of their ancestors. During this feast, an image of the god Amun was conveyed in a procession from his temple at Karnak, on the East Bank of the Nile, across the river to pay visits to various mortuary temples, before resting overnight in the sanctuary of the temple of Hatshepsut at Deir el-Bahri. Betsy Bryan has recently contributed further to an understanding of the part of the festival called the "feast of drunkenness." See Siegfried Schott, *Das schöne Fest vom Wüstental: Festbräuche einer Totenstadt*, Abhandlungen der Geistes und Sozialwissenschaftlichen Klasse, Akademie der Wissenschaften und Literatur, Mainz, Jahrgang 1952 (Wiesbaden, 1953); Betsy Bryan, "The Temple of Mut: New Evidence on Hatshepsut's Building Activity," in *Hatshepsut:*

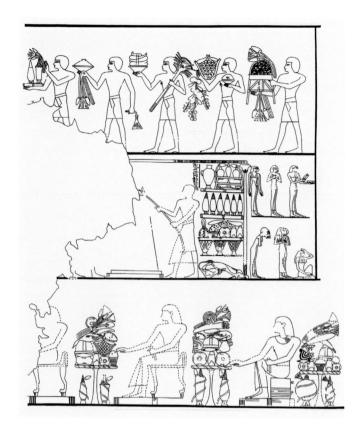

FIG. 72 Statue ritual. Uppermost register: Servants bring food and flowers. Middle register: The statue of the tomb owner (only the base and his staff are preserved) is approached by his son Senwosret; behind are food offerings and female mourners. Bottom register: participants at a meal that accompanied the statue ritual. Painting in the Theban tomb of the vizier Rekhmire (TT 100), 18th Dynasty, ca. 1450–1420 B.C. Drawing from Norman de Garis Davies, *The Tomb of Rekh-mi-rē at Thebes* (New York, 1943), pl. 109

From Queen to Pharaoh, edited by Catharine Roehrig, exh. cat. (New York, 2005), p. 182.

None of the images depicting these festivities can therefore be used to reconstruct the occasion at which the pots, collars, and animal bones in the Davis find were used. However, a few other representations among the paintings and reliefs in non-royal Theban tombs have recently been interpreted as depictions of communal meals held in connection with funerals. The meals depicted in this context (fig. 72) belong to the cycle of rites around the statue of the deceased that also included the instal-lation of offering booths and ended in a smashing of the vessels used in the booths (fig. 5). These meals are definitely not of the convivial nature that Winlock's texts attribute to the

"funeral meal," they do not take place by the tomb entrance, and only the traditional broad collars are worn, not the floral versions. See Heike Guksch, *Die Gräber des Nacht-Min und des Men-cheper-Ra-seneb Theben Nr. 87 und 79* (Mainz, 1995), pp. 62–68.

p. 47 **They read as follows:** Winlock's transliterations have not been modified in his text.

p. 48 **suggest that there were eight persons who sat around the table together.** The presence of objects in groups of eight suggests a doubling of the ritually significant number four, found often in ancient Egyptian texts. The tables of the time were small and only suitable for one or two people. If a larger number shared a meal, each person sat at his or own table.

p. 48 **broke practically all the pottery** Note that most of the pots here (figs. 17, 48–56) have been restored from shards by the Museum.

p. 48 **B Four wine bottles** Winlock presumably based this identification of the bottles with long necks (fig. 49) on a faint resemblance to wine jars found in the tomb of Tutankhamun. However, the latter vessels have handles, making them of a

FIG. 73 A water bottle and basin for washing the hands after a meal. Wall painting in Rekhmire's tomb. Drawing from Norman de Garis Davies, *The Tomb of Rekh-mi-rē at Thebes* (New York, 1943), pl. 111

different type (see Reeves, *The Complete Tutankhamun*, pp. 202–3). Depictions of bottles shaped like the ones found in the embalming cache instead show them being using for hand washing (fig. 73). They are water bottles and, according to ancient Egyptian custom, could also have been used for libations.

p. 57 **the bones which made up part of the contents of the jars** Winlock's record of the collection of bones strongly suggests that these were not just remains of meat cooked to be eaten but of sacrificial offerings. What he describes as a shoulder blade and connecting bones of a cow that show signs of hacking with a cleaver are, in fact, most likely bones from the foreleg of a cow or ox—the part that was traditionally presented as an offering. Likewise, the presence of heads, legs, and feet among the fowl bones—which photographs in the Museum archives show to have been among the finds (figs. 57, 58)—suggest that the ducks and geese were brought in as offerings rather than food. Salima Ikram has observed that bird legs are rarely present among the food deposited in tombs. See Salima Ikram, *Choice Cuts: Meat Production in Ancient Egypt* (Leuven, 1995), p. 61.

p. 58 **flower collars that had been worn by those present at the banquet.** No depictions of the meals that took place in connection with burial rites show "guests" wearing floral collars (fig. 72). Even more strikingly, no wall painting in Tutankhamun's tomb (Reeves, *The Complete Tutankhamun*, p. 72) or in any of the nonroyal tombs of the period represents living participants at a funeral adorned with floral collars; only the mummy itself is decked out with abundant flowers and garlands. Add to this the fact that the collar covering the shoulders and chest of Tutankhamun's third coffin (p. 8; fig. 67) was composed of a selection of plants and flowers similar to the collars discovered by Davis, and one is inevitably led to the assumption that the collars in Davis's cache were either part of the adornment on the pharaoh's body during the embalming rites or were created for one of the coffins (or another piece of burial equipment) but then not used. See Percy Newberry, "Report on the Floral Wreaths found in the Coffins of Tut-ankh-Amen" in Howard Carter, *The Tomb of Tut-ankh-Amen*, vol. 2: *The Burial Chamber* (London, 1927), pp. 189–96; and Renate Germer, *Die Pflanzenmaterialien aus dem Grab des Tutanchamun*, Hildesheimer Ägyptologische Beiträge 28 (Hildesheim, 1989), pp. 10–12.

FIG. 74 Queen Nefertiti puts a collar around King Akhenaten's neck. Shrine stela fragment from Amarna, limestone with remains of paint, h. 12 cm (4³/₄ in.). Ägyptisches Museum und Papyrussammlung, Staatliche Museen, Berlin (inv. no. 14511)

The intended effect of such adornments for mummies and coffins must have been similar to what is assumed to have been the role of the flowers and floral collars in the "Beautiful Feast of the Valley" celebrations: rejuvenation. See especially Norman de Garis Davies, *The Tomb of Rekh-mi-Rē at Thebes* (New York, 1943), pp. 59–63, pls. 64–67. In addition, some of the plants may have had medicinal uses; see James P. Allen, *The Art of Medicine in Ancient Egypt*, exh. cat. (New York, 2005), pp. 11, 43–47, 99.

It should also be kept in mind that during the Amarna Period (ca. 1353–1336 B.C.) and into Tutankhamun's reign, a special relationship was believed to exist between the royal family and the natural world (figs. 74, 75). See Arnold, *The Royal Women of Amarna: Images of Beauty from Ancient Egypt*, pp. 104–7. On the frequency at Amarna of collars and necklaces made of faience but depicting plants, see Andrew Boyce, "Collar and Necklace Designs at Amarna: A Preliminary Study of Faience Pendants," in *Amarna Reports VI*, edited by Barry J. Kemp (London, 1995), pp. 336–71.

The plants used in the collars were identified by Renate Germer. She determined that Tutankhamun's funeral took place sometime between the end of February and mid-March, which corresponds with the seasonal selection of plants in the collars. A slightly later date of March to April is advocated by Rolf Krauss. See Germer, "Die Blütenkragen aus RT 54," in *Miscellanea Aegyptologia Wolfgang Helck zum 75. Geburtstag*, edited by Hartwig Altenmüller and Renate Germer (Hamburg, 1989), pp. 89–95; Krauss, "Nochmals die Bestattungzeit Tutanchamuns und ein Exkurs über das Problem der Perseareife," *Studien zur Altägyptischen Kultur* 23 (1996), pp. 227–54; see also F. Nigel Hepper, *Pharaoh's Flowers: The Botanical Treasures of Tutankhamun*, 2nd ed. (1990; Chicago and London, 2009), pp. 9–10.

For the convenience of users of this book, Germer's description of the three collars is translated below:

MMA 09.184.214 (fig. 64): rows 1–4 from the neck: berries of *Withania somnifera* (L.) Dun. on a strip of palm leaf; row 5: groups of three, at the ends four, *Withania* berries alternating with groups of small, disk-shaped faience beads on a strip of palm leaf; row 6: leaves of the olive tree (*Olea europaea* L.) with the green upper side showing. Each olive leaf enfolds a petal of the blue lotus (*Nymphaea caerulea* Sav.); row 7: leaves of *Mimusops schimperi* Hochst. and flowers of a *Picris* species. Presumably, it is *Picris asplenioides* L. that also appeared in the collars on Tutankhamun's coffin; row 8: *Mimusops* leaves and *Picris* flowers; row 9: cornflowers (*Centaurea depressa* Bieb.); rows 10–12: *Withania* berries on a strip of palm leaf; row 13: groups of six or seven, at the ends twelve, *Withania* berries alternating with blue disk-shaped faience beads; row 14: olive leaves with the green upper side visible, each leaf enfolds a petal of the blue lotus; row 15: *Mimusops* leaves; row 16: groups of cornflowers and *Picris* flowers with rather long stems, so that the flowers hang down beyond

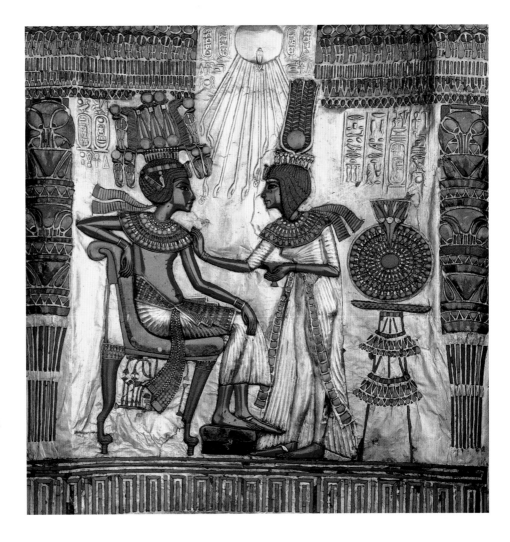

FIG. 75 Queen Ankhesenpaaten/ Ankhesenamun, wearing a floral collar, touches the collar around Tutankhamun's neck; another collar is displayed at right. Back of Tutankhamun's throne, wood covered with gold leaf, inlaid with silver, faience, colored glass, and stone, h. (of complete throne) 102 cm (40⅛ in.). Egyptian Museum, Cairo (JE 62028)

the end of the papyrus foundation of the collar. The ends at both sides of the collar consist of olive leaves that show the green upper side and cornflowers on long stems.

Color scheme of this collar: red berries, blue faience beads, blue cornflowers, light blue lotus petals, yellow *Picris* flowers, and dark green olive and *Mimusops* leaves.

MMA 09.184.215 (fig. 59): row 1 from the neck: olive leaves in groups of three with the green upper side showing, alternating with three other leaves that show the silvery underside of the leaf; row 2: remains of a row of very crinkled leaves that are almost completely hidden behind the olive leaves. No certain identification possible. But they are very similar to the ones of row 7 in 09.184.216. I think it is possible that these are leaves of the wild celery (*Apium graveolens* L.), which also occur in the collar on the third coffin of Tutankhamun. Row 3: after a gap that allows a view of the papyrus foundation of the collar, olive leaves, all

showing the silvery underside; row 4: *Mimusops* leaves; row 5: cornflowers on long stems hanging over the end of the collar's papyrus foundation. The ends at both sides of the collar consist of rows of olive leaves whose silvery underside is visible.

Color scheme: whitish papyrus foundation, red linen at the neck, dark green olive and *Mimusops* leaves, silvery olive leave undersides, and blue cornflowers.

MMA 09.184.216 (fig. 65): row 1 from the neck: groups of *Withania* berries alternating with groups of blue disk-shaped faience beads on a strip of palm leaf; rows 2–3: *Withania* berries; row 4: as row 1; row 5: as rows 2–3; row 6: olive leaves showing the silvery undersides; row 7: groups of much disintegrated leaves that cannot be identified with certainty. They look similar to the ones in row 2 of MMA 09.184.215. Possibly these are celery leaves, plus groups of *Mimusops* leaves; row 8: *Withania* berries; row 9: olive leaves, each one of them

either the green upper or the silvery underside; row 10: alternating groups of *Withania* berries and blue faience disk-shaped beads; row 11: olive leaves all showing the silvery underside; row 12: *Mimusops* leaves, in four places groups of plants that cannot be identified with certainty. They consist of floral stems of an *Umbelliferae* species at the ends of which are occasional flowers or tiny immature seeds. To left and right in each group are the same leaves as in row 7. It is not possible to identify the *Umbelliferae* species, but based on the shape of the seeds one might compare them with celery, like the leaves. An identification as celery would fit the placement of Tutankhamun's funeral between the end of February and the middle of March, a time already determined on the basis of the flowering date of plants in the Tutankhamun coffin collar.

Color scheme: whitish papyrus foundation, red linen, red berries, blue faience beads, silvery olive leaves, green olive and *Mimusops* leaves, and the probably fragrance-rich green celery leaves and flowers.

FIG. 76 Drawing by Lindsley F. Hall. Plate VII in H. E. Winlock, *Materials Used at the Embalming of King Tūt-ʿankh-Amūn* (1941). These drawings correspond to objects illustrated in figs. 17–21, 31–33, and 46–47 (as well as objects that were deaccessioned). The scale given in the original plate is not valid for this reproduction.

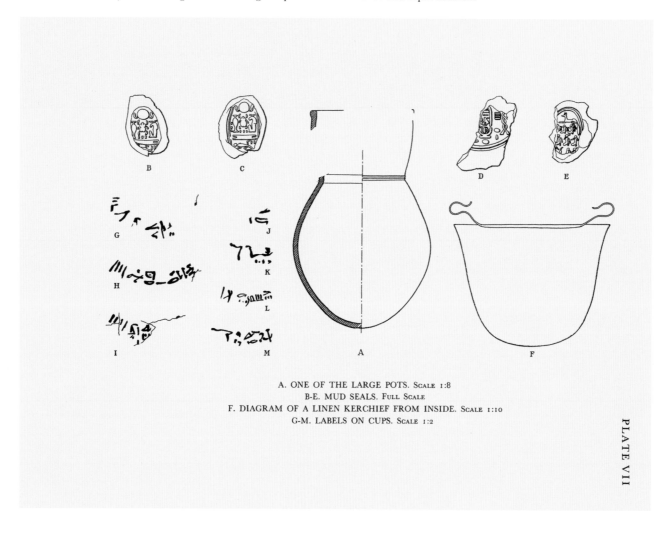

A. ONE OF THE LARGE POTS. Scale 1:8
B-E. MUD SEALS. Full Scale
F. DIAGRAM OF A LINEN KERCHIEF FROM INSIDE. Scale 1:10
G-M. LABELS ON CUPS. Scale 1:2

PLATE VII

PLATE VIII

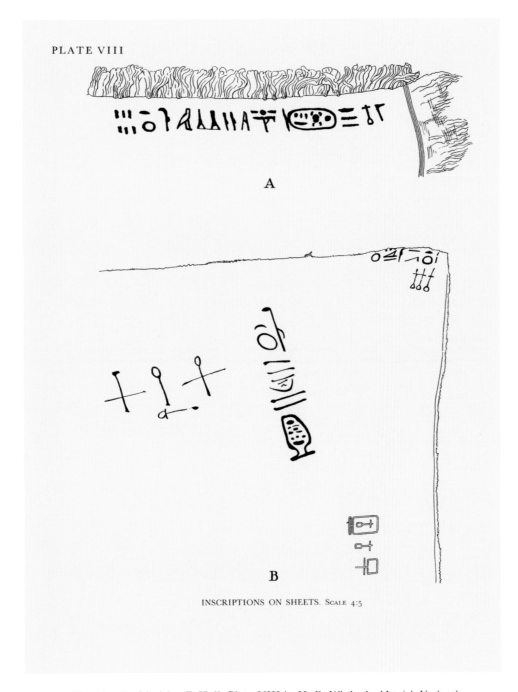

A

B

INSCRIPTIONS ON SHEETS. Scale 4:5

FIG. 77 Drawing by Lindsley F. Hall. Plate VIII in H. E. Winlock, *Materials Used at the Embalming of King Tūt-'ankh-Amūn* (1941). These drawings correspond to the objects illustrated in figs. 24 and 25. The scale given in the original plate is not valid for this reproduction.

PLATE IX

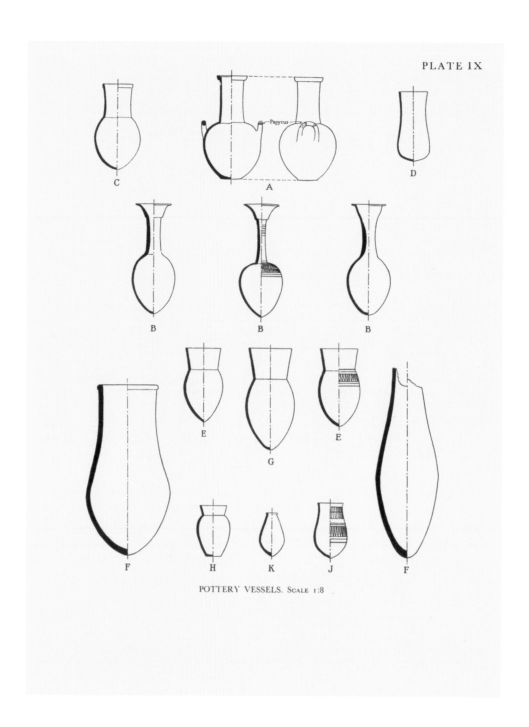

POTTERY VESSELS. SCALE 1:8

FIG. 78 Drawing by Lindsley F. Hall. Plate IX in H. E. Winlock, *Materials Used at the Embalming of King Tūt-'ankh-Amūn* (1941). These drawings correspond to objects illustrated in figs. 17, 48–49, 51, and 53–54 (as well as objects that were deaccessioned). The scale given in the original plate is not valid for this reproduction.

PLATE X

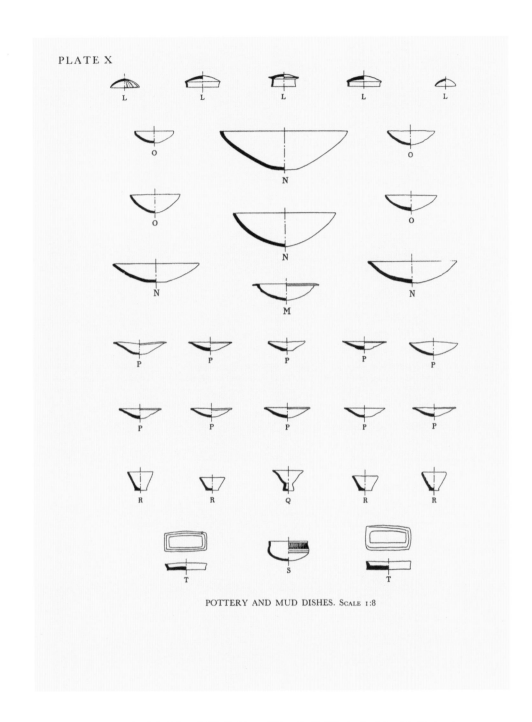

POTTERY AND MUD DISHES. Scale 1:8

FIG. 79 Drawing by Lindsley F. Hall. Plate X in H. E. Winlock, *Materials Used at the Embalming of King Tūt-'ankh-Amūn* (1941). These drawings correspond to objects illustrated in figs. 39, 43–44, 51, and 54–56 (as well as objects that were deaccessioned). The scale given in the original plate is not valid for this reproduction.

ACKNOWLEDGMENTS

I wish to express my sincere gratitude to my colleagues at The Metropolitan Museum of Art who have made this book possible: Anna-Marie Kellen, Senior Photographer; Robert Goldman, Assistant Photographer; Barbara Bridgers, General Manager of the Photograph Studio; Ann Heywood, Conservator; and Jenna Wainwright, Associate Conservation Preparator, in the Department of Objects Conservation; Florica Zaharia, Conservator in Charge, and Emilia Cortes, Associate Conservator, in the Department of Textile Conservation; Harold Koda, Curator in Charge, and Jessica Regan, Research Associate, the Costume Institute; and Marsha Hill, Curator, and Adela Oppenheim, Associate Curator, in the Department of Egyptian Art. Marco Leona, David H. Koch Scientist in Charge, Department of Scientific Research, gave valuable advice, and Mark Wypyski, Research Scientist, analyzed natron and sawdust. In the Metropolitan Museum's Editorial Department, the valuable input of the book's editor, Nikki Columbus, and the decisive support from Peter Antony, Chief Production Manager; Margaret Chace, Managing Editor; and Gwen Roginsky, General Manager of Publications, are also highly appreciated. Thanks also go to the book's designer, María José Subiela, and production managers Félix Andrada and Gonzalo Saavedra at Ediciones El Viso, Madrid. My colleagues Geoff Emberling and Emily Teeter at the Oriental Institute Museum, University of Chicago, and Katja Lembke, Roemer- und Pelizaeus-Museum, Hildesheim, have responded in the most collegial manner to requests for photographs of pieces in their collections.

Dorothea Arnold